The Arrière-pays

THE FRENCH LIST

The Arrière-pays

YVES BONNEFOY

Translated and Introduced by

STEPHEN ROMER

LONDON NEW YORK CALCUTTA

This volume is published through the Tagore Publication Assistance Programme, with the support of Institut Français en Inde, Ambassade de France en Inde.

Seagull Books, 2012

First published as *L'Arrière-pays* by Yves Bonnefoy, 1972.
© Éditions Gallimard, 2003

English Translation © Stephen Romer, 2011

ISBN-13 978 0 8574 2 026 8

British Library Cataloguing-in-Publication Data
A catalogue record for this book is available from the British Library

Designed and typeset by Bishan Samaddar, Seagull Books, Calcutta, India
Printed and bound by Hyam Enterprises, Calcutta, India

Contents

I

L'Arrière-pays is at last available in English. It might be of some interest to the reader coming new to this text if I sketch in a little of the background.

It began forty years ago, when the French, or rather the Swiss, publisher, Albert Skira and his successors, refused point blank, and without explanation, to allow the publication of the book in other languages. Interested publishers—and there were many, especially in Italy—were startled to receive short, dry letters, refusing their request. What was the reason for this? The book had been published in the collection *Les sentiers de la création* (The Paths of Creation, 1972), which was soon to become prestigious, thanks to the authors that Gaëtan Picon managed to assemble, among them Claude Lévi-Strauss, Roland Barthes, Pablo Picasso and Francis Bacon, but it was also due to the striking originality of a presentation in which text and illustration worked throughout in close association. The idea was that, rather than allowing the publication one by one of these volumes in different editions, Skira, now relocated from Geneva to Milan, would republish the whole collection simultaneously in French and

other languages. Meanwhile, the French edition of my book was soon sold out, and never republished except in 'pocket' form. It was only after several approaches of different kinds that, in 1992, Skira at last allowed my book to be reprinted in its original form, along with one or two of the others.

But nothing appeared in the other languages, except, a few years later, a translation into Armenian, and then into Russian, chiefly because these countries felt less bound by the contractual laws in force between the countries of the West. Actually, they did well to ignore them, since my publisher had abused his rights, and when at last Gallimard took an interest in the matter and decided to draw up a new contract and republish *L'Arrière-pays*, Skira, duly informed, did not react. This in turn opened the way to its publication in translation. And the first of these to appear was in Italian.

But with the English edition other difficulties arose, due mostly to the hybrid and unclassifiable nature of the book. Was it poetry or prose? Was it about the paintings or about the far-flung places in the world that figure in the illustrations, or was it about the purely subjective relation they have to the self, to the speaker, who never declares exactly who he is, or where he is from, or when he is writing? Should the illustrations be beautifully reproduced, as in an academic monograph, or should attention be paid

to the text, with poorly reproduced black-and-white images of an artwork or a church that exert the greatest hold over the imagination? There seemed to be lacking in the English-speaking literary tradition examples of works in prose, like André Breton's *Nadja* (1928) or *L'amour fou* (*Mad Love*, 1937)—published in France between the wars—which have continual recourse to images in a vein of free association. The title of the book also proved to be a problem, since it takes on many nuances throughout the text. 'Hinterland' has harsh, even military, associations to the French ear, and is quite unable to render what is a straightforward phrase, although it naturally sets the mind dreaming. In the same way, 'back-country' is too heavily charged with ideas of poverty or even backwardness, when my own *arrière-pays* is a dream of civilizations superior to our own. I found in the adjective 'landlocked' a good deal of what my phrase contains but then some examples of my *arrière-pays* are islands . . .

For *L'Arrière-pays* to come out in English, a publisher as courageous and intuitive as Naveen Kishore was required. And a translator as lucid and tenacious as Stephen Romer who, over many years, kept the project alive.

II

Bringing my 1972 essay to mind, now freshly arrayed in the English language, prompts me to ponder it again. This

is something I have in fact done before, and on similar occasions, for the Armenian edition, the Italian edition, and more recently at a colloquium in which I developed some notions concerning the imagination that are linked to my earlier book but which I did not include at the time. Today, I am tempted to think of the *arrière-pays* in terms of what the English language contributed to it: what I see are those dreams of the 'elsewhere here', and they have specifically American locations. I think of those great highways leading to some endlessly deferred horizon, and the strange place-names, full of promise, Phoenix, New Hope—how even now they stir up old desires and fill them with possibility! In the actual book, I lingered over the name 'Bethlehem Steel'.

But I also find myself thinking about the Arabian tale of the genie in the bottle. Shut up in his tiny glass prison, he spends centuries in the swell of the sea, until the bottle is caught in the nets of a fisherman who frees him. Alas, had he been freed earlier he might have loaded his benefactor with gifts but, because he has waited too long and because he no longer believes in anything, he wants to kill him . . . Luckily, the fisherman has some knowledge of psychology and he finds a ruse whereby the genie re-enters the bottle, which he promptly re-corks and throws back into the sea.

This parable suits me very well.

Let me say immediately that a translation, especially into English, is a significant event. It allows the book's author, if he knows the language, to encounter himself in a new light which may lead him to greater self-understanding. I do know English, certainly well enough to read myself in translation. So here I am, confronted with a text that I had rather forgotten. It was shut up in the bottle of my memory—of my unconscious—whose walls were made up of the words, sentences and images which I left behind when I moved on to newer ones, leaving the bottle to roll about in my past. Today, I open it, and something is going to emerge. What shall I do? What should I do? Is this not a good moment for a bit of clear thinking?

An especially good moment, I would say, because of my tendency, at this time in my life, to revisit some of my writings, even the very early ones. Poems that had remained obscure have since become clearer because, with the passage of time, aspects of the poetic project have been revealed to me and I can better grasp the meaning of thoughts that were up until then embryonic and confused, and scarcely strong enough to survive outside the unconscious. Shall I do the same with *L'Arrière-pays*? Shall I open the bottle?

But why does the old Arab story come back to me, warning me that to open it would be to risk death and urging me to throw it back into the sea?

Why? Alas, I know all too well! It is because in *L'Arrière-pays*—and this is what sets it apart from my other books—I took the risk of confronting head on a particular temptation I was prey to, arguing that I had to struggle with it, saying that I had struggled with it, imagining that I had triumphed over it. And the upshot of this struggle to think things through was that I could put in place a different solution, one that I consider the true one, which has guided my work, inhabited my words and governed my poetic choices. And now this bottle comes to the surface. But it was I who had thrown it into the sea; having seen through its unreality, I sealed it with a dream and flung it back into what I now considered no longer a part of me.

Now that it has returned, I can open it up; but I know what stops me from doing so. If I refrain, it is out of fear that the old dream, the same dangerous fascination will take hold of me again, wrecking my hard-won truth, dividing me within myself—which would indeed be a kind of death. Were I to take up *L'Arrière-pays* and read it through word by word, as I do when reading my work in translation, would I not get caught once more in the snares it describes all too well, for me at any rate, and thereby lose all the good which my possibly ephemeral victory conferred on me?

Shall I risk it? I have done so, in part, in the two further essays included here, 'The Place of Grasses' and 'My Memories of Armenia'. But do I really shake off the obsession in those pages? Are they not rather an alarming symptom, a secret desire to live the great phantasm again, which would suddenly swell in size?

I hope this is nothing more than anxiety but, all the same, today I shall be prudent, and try to persuade the metaphysical dimension that has opened up to fold itself back into the text, which I shall ponder but not now. The preface I wrote for the Italian edition, also included in this volume, adopts a reassuring position in relation to *L'Arrière-pays*, but it is also a truthful one, and it is to that plank that I shall cling, where it floats alongside the bottle on a nameless sea.

2012

Translator's Note

This translation of *L'Arrière-pays*, and the later texts associated with the book, has occupied me, on and off, for several years, and Yves Bonnefoy's subtle thought for even longer. I can think of few contemporary prose stylists whose thought and whose syntax are so intimately fused; with Bonnefoy, the reader receives the sense of following a thought process as it unfolds, sometimes even as it discovers itself. The poet's long, sinuous sentences have become in his hands an instrument of great versatility. Sometimes the act of translation has involved me in a kind of apnoea, a plunge through the twists and turns of the thought, trusting that I shall surface at the end, like the swimmer described in Chapter 1, 'wreathed in seaweed, broader in brow and shoulders'. Where absolutely necessary, I have interpolated a semi-colon or dashes, since the comma in French can bear a heavier burden than it reasonably can in English. On the whole, however, I have respected the syntax as it stands.

Three recent texts, related most directly to *The Arrière-pays*, are included in this volume at the request of Yves Bonnefoy, for whom they constitute the further thoughts and nuances, that, in fact, he announces, at least as an update requiring to be set down, in the closing pages of

Chapter 5 of the original text. Taken together, the three recent texts may be considered a completion (in as far as this is possible) of the exploration begun in *The Arrière-pays*.

There are many fine translators, and interpreters, of Bonnefoy's work, and I owe a great deal to them. For their help and encouragement over the years I should like to thank four of them in particular: Mary Ann Caws, John Naughton, Anthony Rudolf and Richard Stamelman. Heartfelt thanks also to my publisher, Naveen Kishore, at Seagull Books. My deepest thanks, for his kindness and his patience, and for his prompt response to my questions, goes to Yves Bonnefoy himself.

Introduction

There are certain works that escape definition. *The Arrière-pays* by Yves Bonnefoy is one of these; to borrow W. B. Yeats' phrase, it is an 'excited reverie', in part a sustained essay on aesthetics, in part a spiritual autobiography. It is also a belated addition to Quest literature, in which undivided 'Presence', and the 'true place', would be the Grail. In its metaphysical false starts, red herrings, riddling enigmas and visionary moments, it even has elements of the supernatural thriller. Bonnefoy, searching for the *arrière-pays*, his 'place of absolutes', follows clues wherever they may be found, whether in Italian painting, the deserts of Asia or in his childhood; he retains something of the sleuth with his magnifying glass. There is a 'novel' that never gets written, a thwarted narrative which, in its auto-destruction, recalls many of the preoccupations of postmodernism. Bonnefoy's vexed attempts, in the drafts of this novel, to further the progress of his protagonist are described with a rueful humour: 'The efforts I made to get him into a hotel or a station merely ended in their conflagration.' Such a confession also reminds us that *The Arrière-pays* belongs to that special category—a poet's imaginative prose. This is by no means an easy work: its catalogue of signs and wonders exists in the medium of

abstract analysis. Even the title, *L'Arrière-pays*, which is subjected to so many nuances throughout the text, cannot be satisfactorily translated into English; hence the decision to retain the French term here. In his war against 'concept', Bonnefoy sets out to give a new, personal nuance to chosen words, and this is a project that requires the invention of his own idiosyncratic, elliptical prose style. But the reader patient enough to adapt to this, and accompany the writer on his complex trajectory, is rewarded, not only by a cleansed perception of painting or landscape but also by an unparalleled insight into the creative process of one of the most thoughtful poets of the age.

* * *

L'Arrière-pays was first brought out in 1972 by the Swiss publisher Skira, as part of its collection *Les sentiers de la creation*. In the summer of 1971, Bonnefoy retired to the village of Bonnieux sur Lubéron in the south of France, and, in three inspired months, produced this text. What had been intended as a largely theoretical essay became, as he worked, the personal, impassioned reverie we have before us now. When the book was published, the poet already had a considerable body of work behind him. In addition to three collections of poems, he had two major collections of essays on poetics and the visual arts (*L'Improbable*, 1959, and *Un rêve fait à Mantoue*, A

Dream in Mantua, 1967) and had recently followed them up with his essay on the Baroque, *Rome, 1630*, published to great acclaim in 1971.

Written on the eve of his fiftieth year, *The Arrière-pays* occupies a special position in the Bonnefoy canon. With rare intellectual and emotional discipline, the poet clearly set himself the task of anatomizing his spiritual trajectory up to that point, following the river back to its source in the intensities of his often solitary childhood. At the same time, he undertook to review his ideas on aesthetics, especially in relation to Italian painting of the Quattrocento—his discovery of which, in the early 1950s, struck him with the force of a revelation. Clearly, this text is in no sense a conventional autobiography: the account of his childhood, for instance, does not occur until Chapter 4. The opening chapter plunges us instead into that haunting anxiety, his *inquiétude*, felt at a crossroads, which finds him staring wistfully at the road not taken, as if 'just *over there* a more elevated kind of country would open up, where I might have gone to live, and which I have already lost'; this vivid apprehension is the opening theme of the book, and is taken up throughout in a series of variations. A little further on, Bonnefoy's visionary aesthetics are broached, dazzlingly, with a first, proleptic reference to his beloved Nicolas Poussin: 'The blue in Poussin's *Bacchanalia with a Guitar Player* has that stormy immediacy, that

non-conceptual clear-sightedness for which our whole consciousness craves.'

To analyze this initiatory phrase in terms of content, the *meaning* of Poussin's blue for Bonnefoy is to be considered in relation to, and against, the 'essentialism' of the French language. We can gloss this term usefully by turning to an interview given by the poet on the occasion of an exhibition, held in Tours, which brought together works by the artists Bonnefoy has written about.[1] In this interview, 'Leurre et vérité des images', Bonnefoy returns to this 'essentialism' of French, its tendency, that is, 'to consider, when it names a thing, that it has seized, not the appearance, but the essential nature of the thing'. One result of this, he maintains, is that 'French is more distant than the other Western languages from the reality of the senses, which painting, for its part, can evoke so easily.' That is why 'the French writer is obliged by his very language to watch the painter at work'. This distancing effect creates in turn a 'desire for immediacy' that painting, and in particular colour, can confer. In addition to *The Arrière-pays*, Bonnefoy has written several short imaginative prose pieces, collected in the volume *Récits en rêve* (Stories in a

1 Yves Bonnefoy, 'Leurre et vérité des images' (The Lure and the Truth of Images) in *Ecrits sur l'art et livres avec les artistes* (Paris: ABM/Flammarion, 1993), pp. 35–78.

Dream, 1987), in which he tries explicitly to 'write as a painter'. In one of these pieces, for example, he tries to overcome the conceptual dilution of the colour red that the word 'red' enacts. As he explains in the interview, his ambition is to 'restore to the colour its absolute status by multiplying to infinity the number of ways of saying it'. And, in later poems by Bonnefoy, 'Hopkins Forest', for instance, in the collection *Début et fin de la neige* (Beginning and End of Snow, 1991), the perceived phenomenon of colour is raised to the level of a quasi-sacred revelation.

In this same important interview, Bonnefoy describes something of the relatively straitened circumstances of his childhood in Tours and, in particular, the absence of 'images' of any kind—a 'penury' as he calls it. This signal lack explains to a large extent the intensity of his emotion when he first went to Italy, which he recalls so movingly in Chapter 3 of *The Arrière-pays*: 'What an impression I received, then, of the end of a long wait, of a thirst suddenly slaked, when I saw some paintings from the first half of the Quattrocento, as well as the architecture of Brunelleschi and Alberti.' Allied to this was also the sheer sensuous, physical pleasure of being in a hot Mediterranean country. But even as a boy, contemplating the few images that did come his way, he was possessed by a different kind of knowledge, 'the suggestion that another

world exists, which contains everything, or nearly, of our own, given that you see the same trees, the same clouds, almost the same houses along the roadside'. Here, in embryonic form, is the obsession that haunts the work's opening pages, of that other, higher place.

Behind this haunting, of course, lies the ancient philosophical debate between Form and Substance, and between the Ideal and the Material. Man's tendency to idealize, that predates Plato, to imagine something *more perfect*, becomes a veritable torture for the author of *The Arrière-pays*. The material world seems to be a place laid with cunning snares for the idealist, forever in quest of a spine-tingling novelty, a slant of light, a secret door giving on to a sunlit landscape, an unfathomable expression in a portrait. The children's story that delighted Bonnefoy as a boy, about an entire city hidden under the desert sands, still preoccupies the grown man, though he clothes the original wonder in analytical language. He draws, for example, on Plotinus, who believed that the essential Unity of Being, or the One, is destroyed by conscious conceptual thought. Bonnefoy's word for the One is 'Presence', and it is the single most important word in his poetics. The protagonist of *The Arrière-pays* is also an inheritor of the impulse behind Romanticism, infused by the same longing for a lost unity, often associated with childhood and with the idealization of landscape and human beauty. It is not for nothing he

quotes that arch-Romantic Gérard de Nerval, as yet another ideal form eludes him—'Lost a second time!'

Idealism is not entirely vain, however, if the reflex behind it can be redirected to an apprehension of primal unity—which also entails accepting things in their infinite *otherness*—or of Presence, in *this* world. As we shall see, it is finally by accepting, and even by rejoicing, in our common imperfection that Bonnefoy can affirm the existence of Presence at the end of the book; its pointing towards 'the true place' no longer a source of anguish but, rather, of consolation. What enables this is in fact a tacit shift from the attempt to seize Presence rationally to an acceptance of it as revelation. To use Bonnefoy's terms, there is a move from Gnosticism to Faith. But we must be careful to distinguish the poet's absolute, his apprehension of Presence in privileged moments of vision, from any revealed religion. In *The Arrière-pays*, he does make passing allusions to established religions, Hinduism and Buddhism in particular, and, in his later poems, to Christianity, but he does so analogically, the better to define his own intimations. It would be wrong, however, to entirely *interiorize* these intimations, for then the enriching obsession with landscape, or with paintings, that is, with exterior phenomena, would have no place.

Presence, or aspects of it, would seem then to be located within material manifestations of this world—and,

throughout this work, Bonnefoy's devotion to creation and to re-creation, remains stubbornly that of the poet. Hence the paradox and the perplexity at the heart of the book. It is stated outright at the opening of Chapter 2: 'I should make clear that if the *arrière-pays* has remained inaccessible to me—and even if it does not exist, as I know, as I have always known—it is not, for all that, entirely unlocated, so long as I dispense with the laws of ordinary geographical consistency and the principle of the excluded middle.' The latter term—a vestige of Bonnefoy's lifelong interest in mathematics—refers to a philosophical problem, namely, the principle or law the acceptance of which commits one to hold that for any statement 'p', the statement 'p or not-p' is true as a matter of logical necessity. In other words, Bonnefoy's Presence is not subject to a Manichean yes or no; we are dealing here with 'hints and guesses'; with faith but not with articles of faith. And this in turn leads to the irony of the poet's response to painting that is often explicitly Christian in subject matter. In what could almost be a metaphor for the post-Christian era, the poet is forever arrested by sheer colour, as with Poussin's blue, or the clearer colours, the *pittura chiara* (literally, 'clear painting') of Piero della Francesca or Domenico Veneziano. And he looks beyond the immediate scene, say, of the Crucifixion or the Holy Family, into the landscape behind. As he says of Piero della Francesca, another of his

elected painters: 'In the same way I can never look at the system of little hills—easy walking, but part of an infinite interior—in Piero della Francesca's *Triumph of Battista*, without saying to myself that this painter shares, among his other concerns, the one that haunts me'—that is, the idea of the back-country, somewhere just out of sight. Again, he rounds on himself later, for treating painting, 'which has its own laws', as a mere epiphenomenon, or screen, in which he might glean further clues on his quest for Presence.

As might be expected, it is difficult to deduce an ethics from Bonnefoy's aesthetics, but we can say that the latter are immersed in an ethical atmosphere which demands a type of behaviour marked by immediacy and wholeness. In a remarkable, visionary passage, the poet tries to describe the nature of the inhabitants of the imagined 'true place':

> Night and day would be like everywhere else at any time. But at morning, noon and evening would be a light so complete, and so pure, in its manifest modulation, that men, so dazzled they could only see against the light, dark forms fringed with fire, with no use for psychology, only the yes and no of presence before them, would communicate as though by lightning —in flashes—with an inspired violence—rooted in untellable tenderness—the absolute revolution.

If Bonnefoy has recourse to the language of apocalyptic vision here, it shows that the 'true place' cannot be encompassed by any coherent philosophic system, still less by a revealed religion. The poet calls upon each individual reader's imagination to help construct this ideal society according to his or her own lights.

* * *

Piero della Francesca was a master of perspective, like Paolo Uccello or, nearer our own day, Giorgio di Chirico. All three are discussed in *The Arrière-pays*, and it is especially in relation to perspective in painting that Bonnefoy develops his opposition between gnosis and faith which, as we have seen, is an important part of the book's dialectics. Perspective is a form of gnosis—an esotericism, that is, or a special knowledge, that allows access to hidden mysteries. In relation to Christian dogma, the Gnostics held unorthodox, if not heretical, views, a belief in hidden alchemical or numerical systems among them. Bonnefoy's 'Gnostic temptation', as he calls it, his anxiety at crossroads, in front of a landscape or a painting, springs from a similar interest in systems that is undeniably part of his intellectual make-up. The present work bears traces of his interest in philosophy and mathematics, especially as they are related to this matter of perspective, which becomes a central metaphor in the book. In an earlier essay on Piero della Francesca,

'Le Temps et l'Intemporel',[2] Bonnefoy gives this analysis: 'Piero asks of perspective to give the proportions, symmetries and the immutable numerical laws behind appearances.' In other words, it is the golden mean as the philosopher's stone. One of the climactic moments of the book, consequently, is when the poet (cast for the moment in his role as 'the historian') closes the perspectivist 'argument' and escapes its hermetically sealed labyrinth:

> [I]t is as though he were looking at a painting which was executed according to the laws of perspective, but from the wrong position, neither in front of it nor on the same level, where the studied effects would be lost in the depth that is glimpsed. He cannot enter wholly into the illusion, therefore, but he can hear the music of those numerical scales, and that is enough to appease him.

In the important afterword, 'September 2004', written for the Italian edition of *L'Arrière-pays*, and included in this volume, Bonnefoy returns at length to the science of perspective. Originally concerned with the representation of the public space, as Kenneth Clark has written, perspective also contains, philosophically, 'the germ of an idea which might save us—if we could believe in it: that through proportion we can reconcile the two

2 See Yves Bonnefoy, 'Le Temps et l'Intemporel' (Time and the Timeless One) in *L'Improbable* (Paris: Mercure de France 1992[1959]), pp. 61–83.

parts of our being, the physical and the intellectual'.[3] Bonnefoy feels perspective as a danger—ideal harmony leading to the illusion, or chimera, of a 'higher place'—but also as the saving science of humane proportion, practically applied in architecture to the 'here and now'. In *The Arrière-pays*, and in the later afterword, the sense of personal drama with which the poet invests his understanding of perspective is one of the most remarkable, complex and original aspects of his thought.

In its context near the end of the book, this passage with the 'historian' functions by means of a brilliantly drawn analogy: Bonnefoy's escape from the toils of perspective mirrors his spiritual acceptance of finiteness, of our mortal condition, and a new sense—which leads him to joy—that 'the earth *is*, and the word *Presence* has a meaning; the dream exists, too, but not to destroy or devastate them.' The dream, the haunted reverie, still exists but—with its hints of transcendence, its approaches to the absolute—it is to *supplement*, rather than to annul, the grandeurs of this world. Bonnefoy forcefully reaffirms this discovery, which has clearly not deserted him in the intervening years, in the interview I quoted from earlier on:

> I want now to stress that Italian art does not only suggest, whether involuntarily or not, a back-country;

3 Kenneth Clark, *Civilisation* (London: John Murray, 1969), pp. 96–9.

it means also a succession of artists who—and precisely because they had lived it themselves, the first to do so—in the end denounced it, finding in the space swarming with mirages, a way through into true reality, that can be lived in here, and be mortal, with all the brilliance, and the deep beauty that only the simple thing can confer.[4]

Bonnefoy eventually finds in the Baroque, which he once described as an art of 'impassioned realism', the most perfect expression of this reality. Even if, as he admits, the style at times comes close to bad taste, it is still, for him, the most generous and affecting acceptance of our mortal condition: hence the rapt sentences on Gian Lorenzo Bernini and Nicolas Poussin with which he concludes the book.

* * *

Among the varied literary sources that Bonnefoy draws upon in *The Arrière-pays*, it seems worth drawing attention to two poets in particular, who figure largely, it seems to me, as tutelary presences: Stéphane Mallarmé and W. B. Yeats. To take Mallarmé first, there is a sense in which Bonnefoy's own poetics have been forged in the heat of sustained argument with those of the great symbolist, and

4 Bonnefoy, 'Leurre et vérité des images' in *Ecrits*, pp. 35–78.

he has returned to the subject frequently. It could even be claimed that Bonnefoy's Presence is the reverse side of the medal to Mallarmé's 'Absence'. To use the terms discussed above, Mallarmé must figure as the ultimate Gnostic who, having so thoroughly extirpated transcendence and decided that men are no more than 'vain forms of matter', turned to poetry as to an arcane science, through which he sought to produce, by verbal alchemy, the 'pure notion'. Clearly, Bonnefoy's finally affirmative poetics of Presence are inimical to such otherworldly ghostliness; and yet, strangely, these extremes meet—Mallarmé's 'absent rose', a pure linguistic notion, arising before us in what would be a mirror image of its Presence. (There is always the paradox, in Bonnefoy, of Presence itself becoming, in its war on concept, blindingly conceptual.) But Mallarmé must remain, I suggest, Bonnefoy's *ennemi intime*. By effecting a complete severance between word and thing, and in that sense abolishing the difficult, muddied but essentially flesh-and-blood relations between the two, Mallarmé is the prophet of 'excarnation', to use Bonnefoy's expressive word. (In those fraught notes written after the death of his son Anatole, Mallarmé, despairing of finding form for them, nevertheless writes a haunting phrase, expressive of the compulsion which is essentially the same for Bonnefoy: 'fureur contre l'informe', fury against the formless.)

In *The Arrière-pays*, Mallarmé's name is evoked at significant moments which reveal how deeply his thought has bitten into its author. In Chapter 2, for instance, we find this: 'The authentically Buddhist countries are too lucid, or too pessimistic (too Mallarméan even): they claim that places, like gods, are only the stuff of our dreams; they reach the void too rapidly for me.' Later on, in a key passage, he seems to descry the whole enterprise of idealization, this time on the Romance, or Dantescan model of idealizing a beloved woman out of existence; to 'abolish' that existence, so to speak, in order to enjoy its immutable form. (Bonnefoy uses the Mallarméan word 'abolish' explicitly.) A little earlier, he makes a statement which, though it targets Mallarmé in particular, seems of vast implication:

> [I]n fact what I remarked in myself, and what I thought I could identify and judge, was the primacy I accorded to the beauty of a work over lived experience. I reasoned correctly that such a choice, by delivering words up to themselves and creating a language out of them, created a universe that granted *everything* to the poet; except that being cut off from the changes of each day, from time and from other people, would lead to nothing, in fact, but solitude.

At the heart of this work, as I have suggested, is Bonnefoy's 'Gnostic temptation', very Mallarméan in kind; so, when

he breaks the perspectivist spell at the end, he is also marking a decisive break from a hermetic system and 'opening up' to the world.

In several texts since *The Arrière-pays*, Bonnefoy has come to use, almost as a shorthand for the Buddhist or nihilistic vision, Mallarmé's phrase, here in English, 'Yes, I can affirm it, we are nothing more than vain forms of matter.' In the two most recent texts included in this volume, 'The Place of Grasses' and 'My Memories of Armenia', published in 2010, in which he revisits the earlier book, Bonnefoy makes explicit the duality of the vision— how Mallarmé's nihilistic *résumé* can be countered by the human act of volition; I can say: that may be so, nevertheless I *found* a civilization on this stone, on this monument, or even on this family house. It is our will (*vouloir*) that there should be being, which we can invest with meaning. And that, *even if it is founded on non-being.* Just as we might consider we have freedom of choice, because we decide so, and sometimes we feel it to be so, when in fact all our choices are fatally circumscribed by conditions arising and mortality. The greatest artists, finally, Poussin and Bernini among them, but also the architect Leon Battista Alberti, seem to be those who most courageously forge their works out of, and despite the awareness of, non-being, which stamps them nevertheless with that acceptance of mortality Bonnefoy experiences in *The Arrière-pays* as a

homecoming. And in latter years, Bonnefoy's further reflections on poetry and aesthetics hold fast to his apprehension of this double vision, but of how one—the idealizing dream of the *arrière-pays*, that has its source in the visionary gleam of childhood—can sustain us in the other, which is the mortal here and now (this is the message, essentially, of 'September 2004'). As a result, the later writings on poetics are remarkably sanguine.

If Bonnefoy is engaged with Mallarmé in something like an Oedipal war-embrace, it is to Yeats that he is attached with a filial admiration and affection. In his introduction to his translations of the Irish poet, he compares the poetics of the two in terms explicitly favourable to Yeats, who finally declares himself for the world of flesh and blood:

> Since Yeats sees no objection to the chances of existence when it attains the intensity it is capable of, why should he then be tempted to devote himself to exclusively verbal construct? [. . .] This beauty of words becomes no more to him, his early manner over, than the blazing out in which the spirit escapes—for no more than an instant, and which is just a reflection of it—its normal inaptitude for living in the absolute [. . .] Illuminating, transfiguring, with Yeats beauty gathers into an image, in a brusque and transitory flare . . .[5]

5 See W. B. Yeats, *Quarante-cinq poèmes suivis de La Résurrection* (Yves Bonnefoy trans.) (Paris: Poésie/Gallimard, 1993), pp. 7–31.

Clearly, these rare instants in Yeats, attendant upon the 'chances' of finite existence, belong to the same order of experience as Bonnefoy's apprehensions of Presence.

As far as *The Arrière-pays* is concerned, it is the Irish poet's vision, or invention, of Byzantium that most exercises Bonnefoy's imagination. Without doubt, Yeats' own 'Gnostic' book, *A Vision* (1925), especially its great closing chapter of visionary history, 'Dove or Swan', has had a particular significance for him. Yeats' inspired, sweeping statements comparing Greek and Christian civilizations and his description of Byzantium—'a little before Justinian opened St Sophia and closed the Academy of Plato' —find an echo in Bonnefoy's text. For both poets, Byzantium represents a 'Gnostic temptation' and, in an earlier essay, the French poet associates it explicitly with his dream of the other country: 'Whenever a ship leaves port, at night, there was that Byzantium of the mind, already glinting like the further shore.'[6] Although Yeats is never named, when Bonnefoy contemplates artefacts from Byzantium, plates in silver and pewter whose 'soft reflecting quality is so simple, so modest and un-material, they seem to speak from a special, luminous threshold', it is helpful to bear in mind the Irish poet's evocation of 'some philosophical worker in mosaic who could answer all my

6 See Bonnefoy, 'Byzance' in *L'Improbable*, pp. 173–8.

questions, the supernatural descending nearer to him than to Plotinus even'. But Bonnefoy recognizes also that for Yeats, as for him, Byzantium is not a safe refuge and that even the mechanical golden bird, emblem of art's autonomy, still sings of mortal change.

And it is impossible, having mentioned Yeats, not to adduce his friend Ezra Pound. Pound's remit in *The Cantos* (1915–62) is wider than Bonnefoy's in that the former would write the poem including history. But they do have in common a passion for Alberti's Tempio Malatestiano: Pound finds in the temple itself, in its harmonies of 'clean line' and carved stone as well as the milieu of great artists that Sigismundo Taraval drew around him to create it, an apex of civilization. Sigismundo, says Pound, 'registered a state of mind, of sensibility, of all-roundedness and awareness'[7] and this is surely consonant with the awareness, the *civilisation avertie*, that Bonnefoy is haunted by at the cross-roads. But whereas Pound is always keen to nail down specifics and labours to define the surrounding economic 'conditions' that allowed for such a concerted flowering of culture, the Tempio triggers in Bonnefoy the enchanted dream of harmony and number that risks luring him once more into the labyrinth of speculation.

7 For his views on the Tempio Malatestiano, see Ezra Pound, *Guide to Kulchur*, Chapter 24 (New York: New Directions, 1970), pp. 159–61.

And yet, both poets rejoice, the Tempio stands in solid stone. *Templum aedificavit.*

* * *

In *The Arrière-pays*, art and artefacts frequently incite the poet to impassioned metaphysical enquiry. With the 'Unknown Feeling' that the protagonist thinks he has divined in the expression on the face of an angel in an obscure predella in Venice, or with the Leonardine smile that hovers around the lips of the visionary woman at the close of Chapter 3, art reaches its apotheosis. Bonnefoy's singular art history has this, finally, in common with Walter Pater's—that art is to enrich the quality of life *here and now*. It is not placed, as it is, say, in T. S. Eliot, hierarchically below religious revelation. We should add that the strong presence of dream and of dreaming in this work and of the tending mother-like presence that appears at the critical revelation of the orangery lays it open also to the teeming but fertile ambiguities offered up by the irrational and the unconscious. The other country, that remote region which can never be fully explicated, nor even definitively located, also allows for the supernatural descent, or for the approach of the absolute, as an integral part of our human experience. When Bonnefoy declares, on the opening page of the book, 'I love the earth, and what I see delights me,' he means just that. The moments

of transcendence, of Presence, cause a joy that is essentially inward, but it is a joy, emphatically, *mediated* by the exterior. His vision is thus an open one that allows, and even encourages, each one of us to draw up a list of our own personalized 'devotions'.

Stephen Romer
Clos Châalis, November 2011

The Arrière-pays

J'ai en esprit
une phrase de Plot
— à propos de
l'Un, me semble-t-il,
mais je ne sais plus où
ni si je cite correctement
" Personne
n'y marcherait comme
sur terre étrangère ".

I have often experienced a feeling of anxiety, at crossroads. At such moments it seems to me that *here*, or close by, a couple of steps away on the path I didn't take and which is already receding—that just *over there* a more elevated kind of country would open up, where I might have gone to live and which I've already lost. And yet, at the moment of choice, there was nothing to indicate or even to suggest that I should take the other route. Often, I have been able to follow it with my eyes, and reassure myself that it didn't lead to a new earth. But that doesn't relieve my anxiety, since I also know that the other country wouldn't be remarkable for any novel aspects of its monuments or its soil. I have no taste for imagining unknown colours or forms, or a beauty superior to that of this world. I love the earth, and what I see delights me, and sometimes I even believe that the unbroken line of peaks, the majesty of the trees, the liveliness of water moving through the bottom of a ravine, the graceful facade of a church—because in some places and at certain hours they are so intense—must have been intended for our benefit. This harmony has a meaning, these landscapes, and these objects, while they are still fixed, or possibly enchanted, are almost like a language, as if the absolute would declare itself, if we could

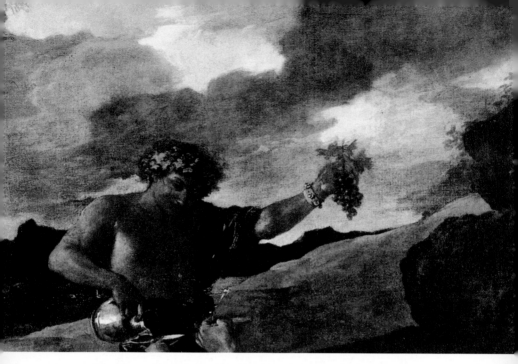

The blue in Poussin's *Bacchanalia with Guitar Player* . . . (p. 27)

only look and listen intently, at the end of our wanderings. And it is here, within this promise, that the place is found.

And yet it is when I attain this kind of faith that the idea of the other country invades me most violently, depriving me of any happiness on earth. For the more convinced I am that it is all a phrase, or rather a music—both symbolic and material—the more cruelly I feel that there is one key missing among those that would let me hear it. We are at odds, within this unity, and what the intuition senses action can neither confirm nor resolve. And if one voice comes through clearly, for an instant, above the sound of the orchestra, well, then the century ends, the

voice dies, the meaning of the words is lost. It is as if from the forces of life, from the syntax of colours and forms, from dense or iridescent words that nature perennially repeats, there is a single articulation we cannot grasp, even though it is one of the simplest; and our shining sun seems a blackness. Why can we not dominate what is there, like looking out from a terrace? Why can we not exist other than at the surface of things, at chance turnings in the path; like a swimmer who would plunge into this process of becoming and come up wreathed in seaweed, broader in brow and shoulders—blind, laughing, divine? There are certain works that can, for all that, give us a fair idea of the impossible potential. The blue in Nicolas Poussin's *Bacchanalia with Guitar Player* has that stormy immediacy, that non-conceptual clear-sightedness for which our whole consciousness craves.

Thinking this, I turn again to the horizon. *Here,* we are afflicted by a curious unease of spirit, or else some snag in appearance, some fault in the manifest surface of the earth, which deprives us of the good it could do us. *Over there,* due to the clearer contour of a valley, or to lightning immobilized one day in the sky, or maybe thanks to a more nuanced language, or a tradition preserved, or to a feeling we don't have (I cannot and will not choose among these things), a people exists who—in a place that resembles them—have secret dominion over the world . . .

Secretly, because I can conceive of nothing, even there, that might challenge our knowledge of the universe. This nation, or place of absolutes, is not so detached from our common condition that we should, in imagining it, surround it with walls of pure ozone. We lack so little here that the beings from over there have nothing to distinguish them from us, I suppose, except the unemphatic strangeness of a simple gesture, or of a remark that my friends, in commerce with them, never thought to question. But do we not tend to overlook the obvious? And yet—if ever the chance came my way—I might perhaps know what to look for.

So that is what I dream of, at these crossroads, or a little way beyond them—and I am haunted by everything that gives credence to the existence of this place, which is and remains *other*, and yet which suggests itself, with some insistence even. When a road climbs upwards, revealing, in the distance, other paths among the stones, and other villages; when the train travels into a narrow valley, at twilight, passing in front of houses where a window happens to light up; when the boat comes in fairly close to the shoreline, where the sun has caught a distant windowpane (and once it was Caraco, where I was told that the paths were long since impassable, smothered by brambles), this very specific emotion seizes hold of me—I feel I'm getting close, and something tells me to be on the alert. What are the

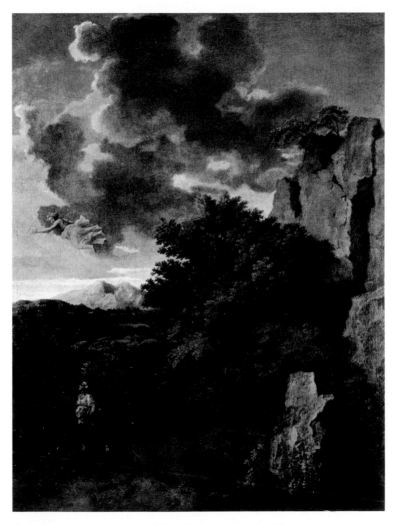

Or to lightning one day immobilized in the sky . . . (p. 27)

names of those villages over there? Why is there a light on that terrace, and who is greeting us, or calling us, as we come alongside? Of course, the moment I set foot in one of these places, this sense of 'getting warm' fades away. But not without it intensifying, sometimes for as much as an hour, because the sound of footsteps or a voice rose to my hotel room, reaching me through the closed shutters.

And then there was Capraia, so long the object of my hopes! Its form—a long modulation of peaks and plateaus —seemed to me perfect, and I could not tear my eyes away for minutes on end, especially at evening, since it had risen out of the mist on the second day of the first summer, and so much higher than where I imagined the horizon to be. Now, while the island of Capraia belonged to Italy, there was nothing to link Italy to the island I was on—it was supposedly almost deserted: so everything was set for this name—which reduced the island to a few shepherds, on their endless journey over the rocky table against the sky, in the jasmine and the asphodel (with a few olive and carob trees in the hollows)—to confer an archetypal quality upon it and make it, as I so wanted it to be, the true place. This went on for some seasons, then my life changed, I came nowhere near Capraia, almost forgot her, and several years went by. But then I happened to take a boat at Genoa one morning, departing for Greece; and suddenly, towards evening, something impelled me to

go up on the bridge and look towards the west where, passing or about to pass very close on our right, were a few rocks and a shoreline. A sighting, an interior shock: a memory in me, deeper than consciousness, or more alert, had already grasped what thought had not . . . Could it be possible, but yes, Capraia was in front of me, Capraia from the other side, the side I had never seen, the unimaginable! In its altered form, or rather in its formlessness (since we were passing so close, scarcely a hundred metres from the shore), the island approached, opened, declared itself—a brief coastline, some scrubland, and nothing else but a little jetty, a path leading off into the distance, a few houses here and there, a sort of fortress on an outcrop— and almost as quickly disappeared.

And then I was seized with compassion. Capraia, you too belong, like us, to this world. You suffer finiteness, you are divested of your secret; recede then, back into the falling night. And keep watch there, having forged other links with me, about which I want to know nothing as yet, because I am importuned by hope still, and so lured onwards. Tomorrow I shall see Zante and Cephalonia, also lovely names, and larger islands, with their mysteries preserved by their depths. How well I understand the end of the Odyssey, when Ulysses reaches Ithaca, already in the knowledge he will have to set off again, an oar over his shoulder, and plunge on into the mountains of another

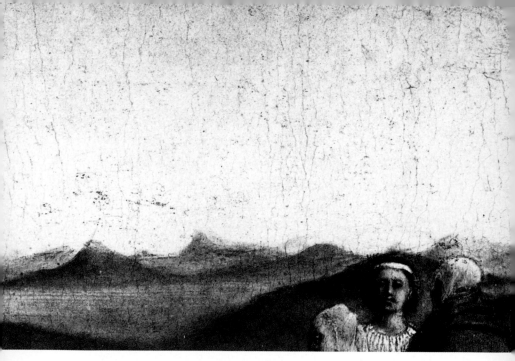

This painter shares, among his other concerns, the one that haunts me (p. 33).

land, until someone asks him about the bizarre object he is carrying, showing that he knows nothing of the sea! If shorelines attract me, the idea of the interior does still more, of a country protected by its gigantic mountains, sealed off like the unconscious. Walking at the water's edge, I watch the foam moving like a sign trying to form, but never doing so. The olive tree, the heat, the salt encrusting the skin—what more could one want—and yet the true path is over there, winding away, following rocky passes that get narrower and narrower. And the further inland I go, in a Mediterranean country, the more strongly the smell of old plaster in hallways, the sounds of evening, the rustling laurel, changing in intensity and pitch (as one

says of a high note), combine to suggest, to the point of pain, traces that are enigmatic, and an invitation impossible to understand.

In the same way, I can never look at the system of little hills—easy walking, but part of an infinite interior—in Piero della Francesca's *Triumph of Battista*, without repeating to myself that this painter shares, among his other concerns, the one that haunts me. But by the same token I love the great plains where the horizon is so low as to be almost masked by the trees and even the grasses. At such moments invisible and tangible become confused, elsewhere is everywhere, the centre, perhaps, just close by. I have been on the trail for so long, there is just one more turning before I see the first walls, or speak to the first shadows . . . And the sea favours this reverie of mine, because it guarantees distance, and suggests such a vacant plenitude to my senses; but not only the sea, because I recognize that the great deserts, or the equally desolate road network crossing a continent, could fulfil the same function, providing the wanderer with space while indefinitely postponing the comprehensive view, which, grasping all, can renounce all. Yes, even the highways of America, and its slow trains that seem to have no destination, and the ravaged landscapes that go before them—but this, admittedly, is to follow my reverie too far into the fanciful. The same year, travelling through Western

Pennsylvania by train, under snow, I suddenly saw the contradictory words 'Bethlehem Steel' on some dismal factory buildings in the middle of a massacred forest; and the same hope stirred in me again, but this time at the expense of truthfulness to the earth. Ceasing to look for excess of being in the intensity of its surfaces, I started imagining instead, in some side street, the most squalid of all, in some blackened yard, a door: and behind it mountains,

How beautiful are these facades! (p. 36)

birdsong and the sea, all smilingly resurrected. But this is the way we can unlearn the limits, but also the strength, of our being-in-the-world. And approaching Pittsburgh, I saw how the Gnostic denial of this world had little by little penetrated the Greek language, born of beauty though it was, and had risen to the notion of a cosmos.

I understood this even better in that my nostalgia itself constituted, in the blackest moments, a refusal of the world, even if nothing, as I have said before, touches me more than the words and accents of the earth. It is true, our lands are beautiful, I can imagine no other, I am at peace with my language, my distant god has only slightly withdrawn, his epiphany resides in the simple: and yet, supposing that the true life is over there, in that elsewhere I cannot situate, then what is here starts to look like a desert. I can tell this from how I act towards what I love, when this obsession grips me. I believe in the light, for example. Even to the point where I imagined the true country born of it, by chance, the accidence of a season and a place where it would have been most intense. Night and day would be like everywhere else at any epoch. But at morning, noon and evening there would be a light so complete, and so pure, in its discovered modulation, that men, so dazzled they could only see against the light dark forms fringed with fire, would have no use for psychology, with only the yes and no of presence inside them, and they

would communicate as though by lightning, with an inspired violence rooted in untellable tenderness, the absolute revolution. But if I dream that, what is the light of the here and now to me, and what do I gather from it? Nothing but dissatisfaction; my desire constitutes its grandeur, and my exile is to dwell within it. How beautiful are these facades! How close to me Leon Battista Alberti feels when he constructs his music in Rimini and Florence! But by catching the sun here, he lights up the horizon; I look to where his intensity is gathered, what is he looking for, what does he know? And what of those Byzantine plates in silver and pewter? Their soft reflecting quality is so simple, so modest, and immaterial, they seem to speak from a special, luminous threshold. In a very old mirror (why did they use that fragile silvering, that soft silver leaf?) are fruits, piled high in abundance on the reflected table, as in 'inverted' perspective, and the face within it has also the indelible quality of a memory. Mysterious objects, that I come across sometimes, in a church or a museum, and stop in front of, like another crossroads. Beautiful and solemn they are, I invest them with all I have seen of the earth: but, every time, it is with an elan that dispossesses it . . . In fact, anything which touches me— however homely it be, a pewter teaspoon, a rusted iron box from another age, a garden glimpsed through a hedge, a rake leaning against a wall, a maid singing in the other

room—can divide my being, and shut me out in exile from the light.

One night a long time ago, when I was still at school, I was turning the shortwave dial. Voices were replaced by others, swelling momentarily and then fading, and I remember I received an image of the starry sky, the empty sky. Men have language, ceaseless speech, but is it not as vain and repetitive as foam, sand, or those empty suns? How poor a thing is the sign! And yet with what certitude we seem at times to be progressing with it, on the prow of a ship, or in a bus moving through dunes, existing superior to it because we can see it forming, flowering and then dying away! Thinking this, I went on turning the dial. And then at one moment I felt I had just passed something that, through poor reception, still awoke the fever in me and compelled me to turn back. I recovered what I had just heard, though the sound was still as precarious: What was it, exactly? A chant, but accompanied by the fifes and drums of a primitive society. The sound of raucous male voices came through, and then, intensely serious, a child's voice while the choir was silent, and then joined by the ensemble—quaverings and growlings in broken rhythms. And surrounding it all, I had an impression, whether or not this was subjective, of space. And then I saw. These beings live high up in a solitude of stones, at the mouth of an amphitheatre at the meeting point of mountain

Their villages stand with blind, heavy facades, often ruined . . . (p. 38)

passes sealed by huge rocks. Above them are rock walls ravined by water and crumbled by saxifrage; a perch for the eagle who climbs still higher. On the horizon, on outcrops and in hollows, their villages stand with blind, heavy facades, often ruined beneath their towers. But where we are is more of a campsite, dotted with fires as night draws in; how to explain the nomadic—if circumscribed—life of these *awakened* societies? This country itself, these men and their music—are they from the Caucasus, or Circassia, from the mountains of Armenia or Central Asia?—but the very words have for me a kind of mythic value, a polar absolute not to be found on any modern map—in fact,

the Mount Ararat to my ark, which ushers in the universe, is similarly surrounded by loud waters, the bare, black horizon, the vague, rapid current.

Soon the chant ended, and someone started talking in an incomprehensible tongue, and then the station was lost in static. The mysterious country had receded and I had invested the other side of the horizon with one of the riches of our own. But it was also from this moment on that I became sensitive to music. A richness, an alchemy from the other side had come to join with our experiences here, and had added to my limited powers . . . And I should here point out that my gnosis, to which I confess, has two kinds of limits. First, even when my dream is at its most intense, our side is not simply or not always dispossessed in favour of the other. What departs with the spirit remains with the body; and the presence remaining is undermined, but intense, as if standing out from a desert, an excess of being in the heart of nothingness, as undeniable as it is paradoxical. Those in exile bearing witness against the country of their exile? But as I've said, the slightest object can merge, at one time or another, into this ambiguous state and remain there, extending and illuminating its interrelations: finally, it is as though the whole world, loved initially like music and then dissolved as presence, *returns* as a second presence, restructured by the unknown but living a more inward relation with myself.

From the other side we have learned the arts, poetry, techniques of negation, intensification, memory. This enables us to recognize and to love ourselves—but also, listening to that original music, to add our own chords, to which things nevertheless respond. Isn't being always an incompleteness,

Those in exile, bearing witness against the country of their exile? (p. 39)

after all, the obscure song of the earth a draft less to be studied than to be recommenced, the missing key less a secret than a task? And what I dream of as an elsewhere must also be, in a profound sense, the future that one day— once the ingathering is complete, and men, beasts and things are called to the same place at the same hour—will show itself here, and absence throws off its mask of pastoral comedy, amid laughter and tears of joy, for the supreme reunion—world recently lost, world now saved?

But there is also this: I am only haunted by another world at those moments, in those places, at those cross-roads, literal or figurative, within the experience of living. As if only part of the latter lent itself to this feverish volatilization, while the other anchors me in the busi-ness of this world which absorbs me for periods of time, untroubled by the horizon; a part that is, in fact, sufficient. There is, finally, a hesitation, between gnosis and faith, between the hidden god and the incarnation, rather than irrevocable choice. There is a negation, but it feeds hun-grily on what it deprecates. And to that must be added the fact that if the haunting remains, an evolution within it began long before. As I move, there is this long ridge of broken fire unfolding endlessly beside me; high and low, it crosses everything and drops away from everything when I approach, only to close up again behind me. And yet, how can I describe it: the point which caught my

eye seems more remote in its spiritual space, while the moment the horizon closed behind me seems closer, and less rapid, as if my valley was lit up and widened. And I also feel the need to understand this double premise better, rather than, as I have done on occasion, merely to undergo it. Most of my memories of the *arrière-pays*[1] are early ones; this is because these are the only 'pure' evocations, more recent ones being over-intellectualized, more articulately sceptical, or at the very least somehow designed to supersede or reconcile the two dominions. Yes, there is a belated knowledge, which reasoned thought must aid even if the latter is limited and contradictory. Clarification can happen not so much through thought as within it, little by little, thanks to an evolution in one's whole being that is vaster and more conscious than words.

[1] A satisfactory translation of the French term *arrière-pays* has proved impossible. The English terms 'back-country', or perhaps 'interior' come closest, but they prove to be unsatisfactory approximations, and cannot render the polyvalent use of the term as it is deployed throughout the text. With the author's agreement, I have decided therefore to retain the French term, which, while being a new coinage in English, has precedents nevertheless, as in the terms borrowed by English, *arrière-pensée* or *arrière-garde*.—Trans.

At this stage, I should make clear that if the *arrière-pays* has remained inaccessible to me—and even if it does not exist, as I know, as I've always known—it is not, for all that, entirely unlocated, so long as I dispense with the laws of ordinary geographical consistency and the principle of the excluded middle.[2]

In other words, the summit has a shadow, which hides it, but this shadow does not extend over the whole earth. Predictably, I am fond of travel guides, or at least of the kind in tiny print with dense paragraphs, in which every place of interest seems to me to offer its own mystery. And when I read, in the admirable guide to Tuscany by the Italian Touring Club (p. 549 of the second edition, 1952): 'a S e E la malinconica distesa delle colline crestace, che cominciano di qui',[3] my blood is stirred once more, and I dream of leaving to find that village; perhaps those words were written *for me*, their flash of promise a signal to begin my quest. I don't consult all guides in this way; certain conditions have to be fulfilled before my antennae quiver and my reactions become irrational and profound. What place

2 In Aristotelian logic, the principle which excludes a third possibility; in propositional terms *a* is either *b* or not-*b*.—Trans.

3 'The melancholic stretch of chalky hills.'—Trans.

does Tibet, for example, or the Gobi Desert hold in my theology of the earth? I name those lands because they have, unlike any other, that quality of remoteness, ruggedness, strangeness. Nothing affects me more than those travel writings from Upper Asia, such as *Beasts, Men and Gods* (1922) by Ferdinand Ossendowski, or the long and monotonous narrative of Alexandra David-Neél. When the latter describes her arrival in Tibet among crowds of flowers so tall and plentiful her porters seem to swim through them; when she stops before glaciers criss-crossed by valleys with entrances sealed by 'enormous clouds', and finally, when she looks down on the whole sacred plain, 'empty and shining under the luminous sky of Central Asia', my attention is riveted and I am ready for a miracle. Yet I know that these plateaus and deserts only compel me so much because of something that happened in my childhood, which adds to their appeal the allure of somewhere completely different on the earth.

The event in question was a story called 'Dans les sables rouges' ('The Red Sands'). I use the past tense because copies of the book may well no longer exist, unless they're hidden away in a few forgotten attics. The 'Red Sands' was little more than a pamphlet, in fact, of some sixty-four small pages; it appeared in a weekly or bi-monthly collection for children, though the publisher in the rue Gazan seems to know nothing of its existence and I myself, strangely enough, mislaid my copy, before my teens, and I cannot

She looks pale. Again, she tries to catch his eye (p. 48).

remember the name of the author. But the idea for the story still seems to me so good that it may well be that this ephemeral publication was only a part or summary of a classic adventure story which others will recognize.

I want to tell it now, because the effect it had on me was deep and lasting. I identified with the archaeologist-hero of the story, and through his eyes I experienced the surprise, and in the end, which I anticipated, the sorrow caused by life's contradictions. Our first glimpse of him is in the Gobi Desert, advancing with a little group of guides and explorers, having left the charted routes behind. He is in search of some ruins that must have been spotted from the air. And every evening they set up camp hundreds of kilometres from the nearest human settlement. This explains their astonishment one morning: a clay tablet placed in front of their tent, which has certainly not been there before. What's more, the inscription seems to have been freshly carved, and reads (in Latin!) *Go No Further*. Disconcerted, they explore the surrounding terrain but find nothing; night falls, and at dawn there is another tablet, and the Latin, and the same warning, more urgent even than before. This time they organize watches. On the third night, by the light of the stars, the archaeologist—a very young man—glimpses a shadow, and hurries to where it hesitates and then stops: it is a girl, dressed in the Roman style, which he recognizes as belonging to a certain moment

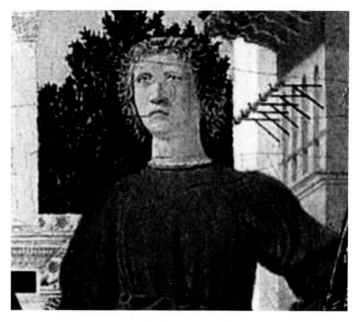

He has not, however, dreamt it (p. 48).

of the Empire. Frozen with astonishment, he calls her, if indeed any sounds came from his throat. But they do, for she turns round and looks at him . . . With what terror, and joy, I, too, had lived through those days of anticipation. And how moved I was when I, too, saw her flashing eyes, her smile and her loose hair in the starlight. But just as the archaeologist is going to speak again, suddenly, and baffflingly, there is nothing there, except the sand, and another clay tablet. He picks it up, doubting all the while what he has seen.

He has not, however, dreamt it. When they return at dawn to the spot where the apparition had melted away, the explorers find a slab, hidden under the sand; they lift it to reveal a staircase, passages and rooms, intermittently lit up by a ray of light coming from the vaulting. Mastering their astonishment, they progress through what turns out to be an entire town which is recognizably inhabited—from a fire, a batch of loaves on the step of a shop—and is, in fact, Roman, to judge from shapes and objects. Suddenly, they find themselves surrounded and then arrested by centurions armed with swords. The sounds of life resume, and the populace reappears. The archaeologists are brought before the prefect, who is surrounded by his officers. He tells them that they have entered a former outpost of the empire which was abandoned by Rome when it weakened, leaving an isolated colony whose sole hope of survival was, literally, to dig themselves in underground. For countless centuries, then, these Latins have lived on in Asia. The isolation which had been their weakness is now their strength and their secret; it is thus imperative that those who have found them out should die. Why have they not taken those nightly warnings seriously? As the prefect speaks, the archaeologist, wracking his brains for his Latin, sees the girl behind a pillar. She looks pale. Again, she tries to catch his eye.

Next, they are taken to a prison, and they know they have only a very short time before their summary execution.

The archaeologist explains to his companions the gist of the prefect's speech, and they try in vain to hatch some plan of escape. They talk—while minutes, then hours go by. Why does no one come? Why this growing silence when a little earlier the guards could be heard patrolling the corridor? Perplexed, and seized by a strange hope, the prisoners listened out—was it true—was there *nothing*? And then the sound of a key in the lock, and the girl is there: 'Go away from here,' she says. But what an exchange of looks, the reparation of former unhappiness, the constraints of childhood, the 'golden leaves' recovered![4] The two children know they love one another and, for a second instant which they share in time, reaching back to their origins, the man tries to speak to the woman, but—'Lost a second time!'[5] She knows the place too well while they can only grope their way through the labyrinth, which is now empty.

Somehow they come to learn that the young Roman convinced her father, the prefect, to spare the strangers and to flee, with his whole people, by way of further corridors, to another underground city, still more remote,

4 See Arthur Rimbaud, 'Matin' in *Illuminations* (1886), where he refers to his childhood: 'N'eus-je pas une fois une jeunesse aimable, héroïque, fabuleuse, à écrire sur des feuilles d'or,—trop de chance!' (Did I not once upon a time enjoy a pleasant, heroic, fabulous youth, to be written on golden pages—too lucky!)—Trans.

5 'Une seconde fois perdue!' The reference is to Gérard's de Nerval's great dream-text of loss, madness and yearning, *Aurélia* (1853).—Trans.

the ultimate Rome deep underground in the desert. They disappear through vaulted passages, which occasionally open out into a round cell with a painting and a lamp. And the door is closed behind them, and sealed up, as the young Frenchman—who wants so much to know and searches high and low through the town—discovers when he finds no trace of it in the seamless walls.

The abysmal desert, winding away infinitely before us! I cannot forget that the place of destiny is there, but it is perpetually unknowable. And I strain to catch any sounds of reunion, of trials ended, of homecomings. David-Neél did, in fact, journey to the confines of the red sands, and has recounted an episode she had the luck to share with a small caravanserai at a crossing point of two trails. A caravan of monks from Mongolia had just arrived from one side; and shortly after, a Tibetan, who had followed the other route. The latter had always known he was not where he ought to be. In his dreams he saw the sandy wastes, the felt tents of a nomadic tribe, and a monastery on a rock. He had wandered since childhood, for long years, without any definite aim, ever driven onwards by his feverish vision. And so it happened that he reached this crossroads, where the caravan had stopped. He felt irresistibly propelled towards these men, and asked to see their leader, whom he recognized. The past—from another life—revisits him like lightning. He was the

spiritual master of that very monk when the latter was still young. They had passed this crossroads once before, on their way back to the monastery on the rock, after a pilgrimage to Tibet. He was able to describe the journey and the building. This was cause for rejoicing, because the monks were on their way to ask the Dalai Lama how they might find their abbot, who had died twenty years earlier and been reincarnated they didn't know where. David-Neél arrived at the very moment these revelations were happening, amid tears and exclamations. And the next day at dawn, she watched as the caravan, at eternal camel-pace, disappeared. The monks returned to their monastery, and the wanderer had fulfilled his destiny.

I, meanwhile, am trying to look over her shoulder, so to speak, to see that empty trail. By chance, the English version of her narrative, *Magic and Mystery in Tibet* (1932), came my way recently, when I was starting to write these pages. At that time also, I happened to be staying in a place like a desert—with immense bridges thrown across it, linking island to island; there were countless silent cars but palm trees as well, large closed gardens, and fires in the grass nearby, and a fragrance carried by the wind into town, as well as sparks that were extinguished in the sea; so the idea of the high plateau with its wandering monks and herdsmen brusquely re-awoke the old compulsion in me, but this time accompanied by incomprehension and resistance. For

They claim that places, like gods, are only the stuff of our dreams . . . (p. 56)

I know very well what distinguished me from the man who sought and found. He desired his true place in which to complete a life that, even there, would still be an entrapment on this earth. His aim was merely to continue on his interrupted quest for total deliverance. As for myself, mindful of transcendence but wanting a location where it might be rooted, it was the latter, this 'vain form of matter',[6] which I invested with the qualities of an absolute . . . Why did I love 'Red Sands' so much? I knew nothing, aged ten, very specific about Rome, except that it was the city to which all roads led; and I imagined monuments and inscriptions that spoke of this, and above them a vibrancy, a light, a seething of fire and purple between heaven and earth. The idea of Rome adds to the archetype of the 'Red Sands', where an elsewhere is concealed, the dimension of a *here* that ordains itself, proudly, the centre. And each time I sense that pride, whether triumphant, expressed in effortless stone, or as if bowed in defeat like those humble clay-and-wattle domes after miles and miles of salt and broken stone; wherever man has wanted to strengthen a wall, decorate a facade, raise terraces; wherever he has wanted to play a music in which his

6 See Stéphane Mallarmé's famous letter of 1866 to Henri Cazalis, in which the poet makes a formal statement of his loss of faith, and the new lucidity on which he founded his poetics: 'Oui, je le sais, nous ne sommes que de vaines formes de la matière!' (Yes, I am certain now, we are merely vain forms of matter!)—Trans.

Where wells have been sunk, or cisterns sealed . . . (p. 56)

fever of anticipation. And this is not wisdom. But it may be—who knows—something better.

I think of India, where this dialectic of self-denying affirmation has been lived so consciously. I spent only a few days there, but it was enough to hear the regular, arborescent, arterial flow of unreality within certitude. We were crossing Rajasthan, and the mountains were opening out and closing behind us in the premonitory silence that precedes some dreams. We stopped in the shade of a tree, where a path led off through an open gateway to a large dilapidated house in the distance; but it was coated in bright colours, decorated with stucco, and some little girls arrived without leaving a trace on the sand, though they danced, and at other instants were quite still; nonchalantly, they offered us water. The summer was immobile, too, and deserted. Then, into this void, came the sound of bells, and a wandering iced-drinks vendor appeared out of the sleepy countryside. The children came back, paid their money, spoke briefly, fell silent; and he, too, remained for a long time, without movement, almost without need, in the light. Other categories, a different experience of time? The depth of space and clarity of gesture mingled to create a feeling of imminence—would it have been just a matter of going in, or at any rate of going a little further along the path until, at a turning, forms would change a little, the future be absorbed and the conflict dispelled? But further on was not

the object of desire, only its most intense expression, which at times even exceeded it. Did I understand Amber? Perhaps it was as though I fell asleep, as the endless land would have it, and the strange over-heavy perfume, and the hypnotic tangle of Islamic inscription in the light. And it is true, I left one of my shades there: wandering through cool rooms, drinking water from large jars. And unappeased if it is true that time has not stopped, so that one day, *per fretum febris*,[8] I must, along with other shades, recover it. The shade is weighed down, however, the face smooth, the lip slightly swollen from so much fruit.

Approaching from a long way off, I watched attentively as the reddish fortress grew in size, with an outer wall that extended bizarrely up and down the slopes, over a ravine, to stop short abruptly on the other side. It looked to me as though the wall wound along at random, because the ground was the same on both sides of it, uninhabited and sterile. But when we got inside the outer wall and then into the upper fortress, passing through shady courtyards and darkened rooms, we reached the high balconies, and suddenly all became clear. The rampart contains nothing one would ever dream of defending; instead, it follows the line of the horizon, as seen from where I am. Everywhere

8 Allusion to John Donne's 'Hymne to God my God, in my Sicknesse' (1623–4). The poet, using a topographical metaphor, prophecies that he must perish *per fretum febris*—'by the straits of fever'.—Trans.

sky level meets desert; some prince had built this wall that, while defending nothing he possessed, embraced the limits of the visible. A place, and its destiny, have been identified with each other, here and elsewhere are no longer in opposition, and I am in no doubt that this was the principal ambition since it is not the empty profusion of essences—as in a Japanese enclosure—that is contained by this long roseate line; rather, it is the stones, the meagre trees, the few houses, a riverbed, the fact of the earth folding back into itself—these are what constitutes a place, in all its presence. In the cycle of the seasons, through drought and monsoon, the king of this patch of sand tried to muffle himself from the irregular pulse of desire. This, at the cost of extreme effort, as of the greatest violence ever done to space, so much so that at certain points the walls are low, almost non-existent, as if exhausted by the audacity of extending *that far*. But the sound waves of the sitar must have accumulated here, undispersed. To be was to rise straight up like smoke undisputed by any wind. I convince myself of that, turning to either end of the ravine, and towards the west, which is already casting shadows. What a conclusion to architecture! Both abdication and triumph. And what refinements, in the feelings and gestures of those who lived here, must have been conferred by the new energy contained by that resonating rock wall! I try and imagine that distillation, that transparency, but what I saw next scratched me like a claw.

I discovered that the wall, in one place, then another (and often, in fact) deviated from the line of the horizon. The gaps were minimal but unmistakable in the setting sun that extended their shadows. A fragment of the outside world appears there beyond the towers, where one of them is missing, concealed by a distant hummock. Had I then imagined the designer's intention, must I then reawaken to my madness and my solitude? No, it is rather that, at first glance, I did not grasp everything—as I do now. The affirmation was willed but so was some admission of its excess. *Elsewhere* was *abolished*, that first instant, but then lucidity returned which left the depths, still intact, to pierce the power of closure. The prince did not want to realize his dream so much as to enjoy the illusion of it. But how is it then that the moment of failure is precisely the moment at which I have the feeling—when my growing anxiety is nipped in the bud—of a reality both deepened and rejoined? . . . What would this sealed and censored depth have brought me if not an exacerbation of the enigma fixed as it now was by chance? But in keeping both affirmation and doubt alive—plucking at the horizon as on a catgut string—the sovereign of Amber mingled some impatience with his longing, added some ardour to his sense of the finite and allowed another music to begin, less learned but sweet and compassionate: in reality, an ancient music consubstantial with life, but one we might

have called, elsewhere in a different age, the spume of passing time, except that here it is apprehended suddenly as a truth. At Amber it is the earth itself—with its fits and starts, its leisureliness and sudden surges like rising and falling rhythms—which lends itself to hands that find the rhythm, and to the words that intend the heart's peace. It is the earth that prompts us to ask why, when the passage of time is broken, a fragrance of eternity is sometimes released.

A little further down the road, at Jaipur, there is a famous observatory built by another prince. In an enclosure today overgrown with grass, the instruments which were used to scan the heavens have now passed back to the earth; I mean, they are no more now than a place into which one may be enticed to spend an hour or so, before one has to leave, and start to grow old again. The group of friends visited the observatory and the palaces, and then went on their way, early one morning. We follow the last street before the *arrière-pays* begins, with its dry, empty mountains; the walls and fronts of the houses are painted pink and caked with stucco, expressive of the slightly rococo grace that is Jaipur's charm, along with the odour of jasmine that is a dissonance, redolent of the unconscious, of sexuality and of death. For another hour at least, the light is not too intense. And I try to imagine, as at Amber, the lives that were lived out in these houses, their little rituals,

their ardours, their tragedies and joys, but rather late in the day I realize that these questions no longer apply to anything. What has happened is that the mountain has drawn in upon us, right and left, to a point where these imitation facades are no more solid than a screen placed in front of it. There is a thin fringe of leaves above the blind arches, the coloured plumage of a last bird and then nothing but the plumb vertical rock face. Like Amber, Jaipur was built as a place where here and elsewhere, those eternal opposites, should fuse. And its beauty was most intense where it put off its pride, like the clearest flame, almost detached from the enduring wood. For what enrichment of their lives on earth did those who scanned the empty sky stake out this place? And why this thirst for elsewhere, that nothing can quench, and why join it to what is perishable here, opening it up to the grief of departure but equally to the joy, the pure joy of returning? Leaving Jaipur, I wondered in the end whether this world of domes, of fortified towns, of fires burning on summits was not, essentially, a path leading away simply from itself, not into the dreamt-of elsewhere, nor to the brink of the great void evoked by Buddhism. It is an earthly path, that belongs to the earth itself. It is a path that would ensure— by turning back upon itself, and as such becoming spirit— revelation and the future.

It is an earthly path, that belongs to the earth itself (p. 63).

I knew very little of Italian painting before my first trip to
Tuscany. Of course I had some idea of the most famous
painters, and the pictures of Leonardo da Vinci came back
to me sometimes as in a dream. But I had yet to discover
what one day would come to affect me the most. In fact, I
had only really looked at the paintings favoured by Surreal-
ism: the *Profanation of the Host* by Paolo Uccello, and those
painted by Giorgio de Chirico in his early manner. Why
had I not tried to find out more? It was doubtless due to a
combination of things. The audacious, abstract use of per-
spective by Uccello segments space, exteriorizes events and
objects, makes form fantastical, colours remote, and every
image nocturnal: I was thus flattered in my Gnostic ten-
dencies but also deprived of a simple beauty which I loved
already more than anything inasmuch as it appeared to me
far off, under the aegis of another world. In the same way

Chirico, in the bold strokes with which he builds up, as in a theatre decor, his squares and colonnades, spoke of an *elsewhere*; but did he promise it? Indeed not, and his over-elongated shadows and stopped clocks expressed an anguish and an unreality which made me doubt the very foundations of classical perspective. Numerically calculated, intelligible, was it not for this very reason a negation of the finite? Did it not obscure, rather than transform, the temporal dimension? I said that I dreamt of another world. But I wanted it to be of flesh and time, like our own, such that one could live there, grow old and die.

After which I finished by going to Italy all the same, and there I discovered, in one unforgettable hour, that what I'd taken in Chirico for an imaginary, even an impossible, world existed, in fact, on this earth, except that here it was renewed, re-centred, made real and habitable by an act of spirit as novel for me as my own being, memory and destiny became at a stroke . . . I visited the churches and the museums and saw on all those white walls the Madonnas of Giotto and Masaccio and Piero, grave, serene, almost upstanding in their flawless presence. These painters had worked with perspective as much or more than Uccello, and had succeeded better than he in freeing the image from its bowed medievalism; but they did not deny the interiority of the object, its being, its transcending of all notional description. In fact, they gathered the slender evidence and

brought to the experience of the senses the light and unity of the sacred; and now I understood that these painters had conceived of perspective to accomplish this task, asking that it should define the horizon, uncover and retain the possible and free the conscious mind of prejudices and chimeras. What I had considered a gnosis, piercing the horizon to find another sky, in fact, defines, like Greek wisdom, the precise and living space of man. And since, after Athens, had come Jerusalem and the promise of Christianity, this awareness of limits was also a faith, which discerned an end in the earthly condition and worked towards Incarnation. What an impression I received, then, of the end of a long wait, of a thirst suddenly slaked, when I saw some paintings from the first half of the Quattrocento, as well as the architecture of Bru-nelleschi and Alberti, who taught that everything had its place, thanks to the new science, in the solar dialectic of the central ground plan![9] In fact, I experienced one of my greatest joys during these first encounters, and it must have been as much physical as spiritual. The stone, the trees, the distant sea, the heat and all the living matter that until then had moved unceasingly under my eyes like the glimmer from still water were restored to me as if now dried out; it was my new birth.

9 Renaissance architecture used the central ground plan in churches and cathedrals, covered by a dome, as in St Peter's, Rome, or Filippo Brunelleschi's Duomo, Florence.—Trans.

The audacious, abstract use of perspective . . . (p. 66)

And yet the struggle, against *excarnation*, was not resolved within me; and far from being a help, day after day, the art of the Quattrocento, in all its massiveness, almost gave it victory. Is it true then that one only desires an elsewhere when the here and now is most strongly felt? Well, it is proof at least that an art of affirmation, a civilization founded on the reality of place, can almost actively suggest another place to the imagination, the dream of an unknown art; it can lead to dissatisfaction and nostalgia and help to deprecate the very world whose value it proclaimed so eloquently.

This dialectic is, in fact, straightforward, and the harm spread rapidly. I had admired in some painters or architects

what may be termed their synthesis of being in a category of space. And as much as the liberation of form, the *paleness of their colours* had touched me, in Domenico Veneziano, Piero and a few others: the traditional opacity of symbolic representation, in which colours have fixed meanings, seemed to mingle with the light of day. I had feared theatrical effects from perspective, like chiaroscuro, but it was not so; the sun came in everywhere, casting faint shadows, the light was born from the very colour of things which recreated earth, drenched in life, as it was on the first morning. This was a radical revolution, though different from the one I had sometimes dreamt of, the violence and mystery of chiaroscuro exacerbated by sudden sunlight. Here all was made plain, and resolved in a single irradiation both inward and gentle—it was in truth a new degree of consciousness achieved; and a freedom that a few spirits had released, directly from felt experience. But whether for the formal conception, or that alchemy of shadow made colour, it was not only the greatest painters who impressed me with their mastery. In front of works they would have found clumsy, ignorant, repetitious— altarpieces commissioned by peasant communities and executed by provincial workshops—I could have all this, if not even more. After all, even with Piero, in that immanence of unity in the representation of things, a tiny fault line is perceptible, which betrays the intellectually

mediated nature of his affirmative act. However empirical he is at the confines of his art, and however conscious of what calculation cannot attain, the fact remains that he thought about his representation, and the instant of thought leaves a trace, like an excess of clarity, and is at the expense of true presence which is grounded in the invisible. And once one has noticed that—this is Chirico again, with his unease—one may come to see only abstraction again in what one had thought solid. By contrast, in the more rustic painting, in some village baptistery or in the apse of some humble church, as if by instinctive faithfulness to the things of nature, consciousness seemed freed from self. By using ordinary fruits, and garlands of leaves and flowers straightforwardly borrowed from Sunday traditions; by a franker depiction of a young body; by an archaic gesture, an old faith was married to a new space, and knowledge and peace were as one.

But why then was it that, instead of reposing in that peace I loved, and could recognize, I became quickly irritated, troubled and impatient to be off, as if, by remaining there, I was missing an opportunity? By a reasoning that I knew, alas, to be specious, but which I found amusing, and which finally captivated me. With all my words, which enabled me to describe Sienese ambiguities, Florentine ambitions, even Piero, I would only travesty these works. But did they not, in any case, repose on modes of perception

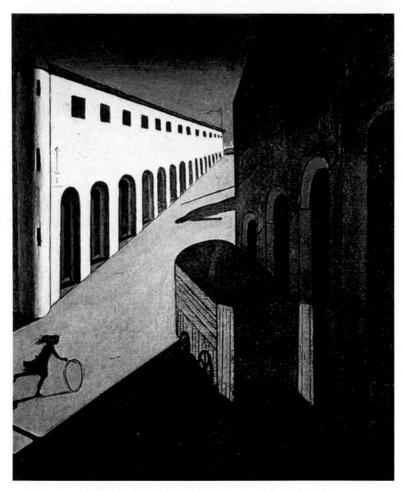

His over-elongated shadows . . . (p. 67)

or being, or even on a way of experiencing the world that I no longer have? And yet these *awakened* societies were small towns and villages . . . Just so! Like anyone else today, I am an inheritor of the Italian Renaissance, so it was not in the large cities that consciousness was different, or I would know about it. No, I had to conceive that this deep awareness had its centre *elsewhere*; and that unlike those cities that have collaborated with history, and lesser ones that have clustered about them, it is in a remote village, in a valley almost sealed off, on a rocky, almost empty mountain, and only there, that it must have appeared. By now, you will recognize the movement of thought, and how the idea of the *arrière-pays* sometimes deprived me, as I have said, of what I love.

But this time it arose at the heart of a very coherent civilization, that I had only glimpsed and was discovering little by little, and which I already loved deeply; and suddenly the obsession intensified, all the more dangerously in that the ups and downs of my enthusiasms for such and such a painter, then for another, might give me the illusion of learning, along the way, to recognize signs and even describe a method. Once I had discovered and praised a particular work, I could more easily recognize its limitations. One retained too much elegance; another was marked, on looking again, by a psychology too facile, read in the expression of grief, pity or love. Awakened, and

aware, yes, but not without a kind of impediment, which belonged to our side; they were only a reflection then of what—*over there*—had shone out in all fullness. But if today I notice in one work a weakness or a falling short, might I not be recompensed tomorrow, by seeing in another work an excess of what I missed in the first? And passing in this way from work to work, might I not get closer to that remote plenitude? At this point in my reasoning, I had to ask myself whether this passage back wouldn't lead, at best, to a place now wilderness, or to a deserted village; but unflaggingly I persuaded myself this would not be so. Where consciousness had once found a key, how could it ever lose it? The man of truth had stopped painting, why I do not know, but he has not disappeared; it is merely a question of learning to recognize him, in his silent distinction, and that is exactly what the paintings, statues and deserted rooms along the way would have enabled. Yes, I had almost reached my goal. Just a few score kilometres from here, or less perhaps, since my preference is for Southern Tuscany, some of Umbria, the Marches and Northern Latium; at first sight crude, because in its purity this time it would be an unknown relation between spirit and appearances—the absolute work existing, with the true country around it . . .

All sophistry, of course, because I was considering art, which is an order with its own laws, as merely an

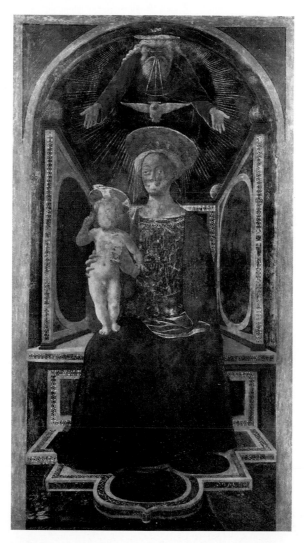

Grave, serene, almost upstanding in their flawless presence . . .
(p. 67)

epiphenomenon which would provide a clue: and meanwhile I had to remain aware that, at the last moment, this method of appreciation by doubt must cease, the ultimate work disclosing absolute presence. And, in fact, I wondered how, when the moment came, I would manage to reverse the direction of my reading. But that only skewered me more completely, because I tried to set myself criteria that would be readable in both directions, like those checkerboard flagstones of the perspectivists. These specious hopes clothed the most ordinary predella in the light of enigma. What could I use as a map or marker on the way?

Just a few score kilometres from here, or less perhaps . . . (p. 74)

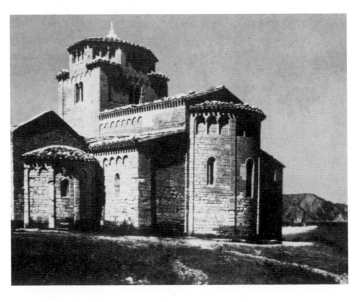

The representation of earth and sky, since the back-country supposes a foreground? The construction of the divine throne, that supreme edifice? Finally, reaching no tangible solution, I hypothesized a kind of magnetism in the hidden centre; and that, if I was searching like this, apparently at random, it was because I was already within the sphere of its influence; and thus I had only to let myself be led, replacing enfeebled thought by impulses from my entire being, the ground of which was truth. So there followed months during which I played with the idea that I was guided, through galleries and towns, by a providence, long disinvested, which I had awoken. Even today, when I visit some gallery and see a painting I had forgotten was there, as I did recently Rosso Fiorentino's *Deposition* in Volterra, I am for an instant seized with hope, as if reminded of my task. How many hours have I spent, not knowing if I was really serious or not, flicking through my *Pistis Sophia*,[10] back numbers of the *Burlington Magazine*, where the photographs are smaller and greyer! Looking at a *Madonna* by Arcangelo di Cola da Camerino, I asked myself: Who has drawn closer to the threshold than he; and must I go to Camerino to take those last few steps of

10 An important Gnostic text, dating possibly from the second century AD. The title is variously translated as 'Wisdom in Faith' or 'Faith in Wisdom'. In Gnostic thought, Sophia comes to represent the female aspect of Logos.—Trans.

the way? But Arcangelo travelled widely himself, and in mysterious manner. He went to San Francesco de Pioraco, and to Riofreddo in Latium. There is also that predella beneath an *Annunciation* by Fra Angelico, which might be from Piero's hand, at some stage in his mysterious beginnings; and he never painted without a reason, or so one might think . . . Still quite archaic in its manner, haunted by a gold sky, it shows a stretch of Lake Trasimene, as you see it coming from Cortona. To leave for Cortona, for a family *pensione* in a random street . . . There would be a green-tiled hall, like the one in the *Profanation of the Host*. And that white-walled room where, suddenly, a painting . . .

I didn't go to Riofreddo in Latium, and to this day I have put off the visit to Cortona. In fact, I have kept to the supposedly important art centres in my explorations of the Italian interior, or the kind of art my reverie considered a distorted reflection of invisible presence. I have to say that my study of Tuscan painting, seriously undertaken, was not, in fact, diverted overmuch from its essential aspects by this dream of outlying provinces; luckily so, because it helped free me from it. The reverie did not affect my reason, although it persisted like a stain on my perception, or like an aura round the image whose meaning, at times, was blurred by its iridescence. And when this aura was strongly marked, it penetrated Tuscan

art, as much as it denied it, with its bizarre light; and from that art, now illuminated, arose a reality that dispersed the clouds. Which was, moreover, predictable. How could I doubt that ontological weight, not the reproduction of appearances, was the primary goal of Italian art, at least up to the end of the Baroque? In this sense my obsession might read its messages wrongly, yet it spoke the same language, and I should surely, one day, understand it clearly. And that message would surely welcome me, also, at the end of my dream, as it had in a way accompanied me throughout. An affirmation and an assumption of our place of existence in Masaccio or Piero? But the dream of a golden age, the attempt at a radical recasting of our perception by numbers, the idea, almost, of another world, uniquely for the mind, is certainly in Marsilio Ficino; but it is there also in Brunelleschi's dome, in Alberti's facades at Mantua; it is also what is meant, or even joined, by that hand, in Piero's fresco at Arezzo, *The Meeting of Solomon and the Queen of Sheba*, which indicates the vanishing point. And to grasp in any real depth the affirmation that had so touched me, made up of contradiction and reprise, of dream as much as science, of a secret overreaching, it was better not to hold to its moments of victory but, rather, to fathom, with a like impatience, the illusions and disillusions, the rekindled hope, the diffractions and the eddies of this Tuscan ambition, which is both extravagant

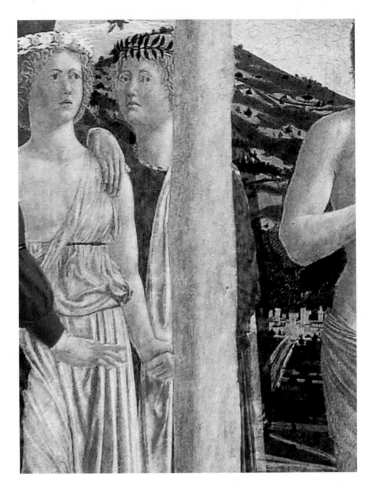

But no, the sun came in everywhere . . . (p. 70)

and lucid and in which pride struggles ceaselessly with wisdom and rigour with stoicism. Almost contemporary with Piero, there is Botticelli in Florence, from whom Mannerism proceeds, which is the art of a desire that never renounces and which sacrifices to it the ground only just discovered. And soon comes Michelangelo who, out of a reluctance to close, left his sculptures unfinished. Pontormo . . . In truth, whoever is sensitized by a desire in itself, an inward-turned elan, a regret, a caprice, by the contradictory existing within unity, the upheavals that traverse beautiful images of peace, and by the music of certain disorders, can be in no doubt that the affirmation of some minds, and among the strongest, issued less from any closeness to the earth than from a moral experiment pursued with persistence. While it was dubious on the purely plastic level, as in the case of perspective, which is a perpetually external measurement, this time their researches issued—and now faultlessly—in an acceptance of destiny. And it is through this ataraxia, in the clarity of asceticism, that it reaches the summit of perception. As I have said, I loved the *pittura chiara*, with its lightened colours. And interpreting it as a fact of pure consciousness, I imagined it as the prolongation from *over there* of an even greater dawning. But I ended up by understanding that it reflected nothing other, after a long struggle against pride—Uccello's demon—than the transparency of the heart. What 'immediacy' there is in that

'purely' plastic notation! But that is how it is. Nothing is immediate, nothing exists even, but everything must be won, everything forged in the fire of existence, and primarily the beauty of the place that existence has made its own.

And anyone who had ranged in spirit over the far, reclusive reaches of Tuscany or the Marches, seeking idly, and loftily, to distort the simple, to fracture the manifest, to flee the difficulties of the human condition—such a one could certainly learn a lot, and not just about art, on the journey back. One day the 'traveller' remarked that, while he had not seen Camerino, nor really desired to get there, he had lived in Florence meanwhile, where he had received, before the figure of Night in the Medici Chapel, his apprenticeship in life. Florence—at times so tense, impatient, black, and at others reconciled; often lost in her dream but never careless of those who suffer; incapable perhaps of the wisdom of Piero (unstable as it is), but altogether more tender in her capacity to calm the feverish—Florence had been for him the wounded, wise and mindful teacher that he needed, and sought. And she showed him, in a lesson he had never grasped before, that it is possible to love images, even if one recognizes non-being in each one of them: for it is true that all these works taken together do not cancel each other out. They enable, rather, a potential deepening of the self and a recognition of its destiny. I remember how, one morning, in a church in Arezzo, I lingered for a long time in front of

a scaled fresco that showed others beneath it, seeking traces of what my demon persuaded me was the hand of Barna. Suddenly an immense weariness came over me. Why Barna, why did I need that shadow? The wall had no issue, in its ruin, other than the unconscious which was projecting my own visions upon it, and which I would do better first to try and understand. I walked out of the church, I think it was San Domenico, and into the burning sun of the square; and performed nothing, of course, other than the usual inconsistent steps and movements of someone who visits and then leaves, pensively, but a tourist nonetheless, whether he likes it or not, a stranger; but a thought had lodged itself in my mind. The traveller, I said to myself, returned to Arezzo. He wanted to revisit a fresco where a few days earlier he had lost the thread, or so he supposed. But he renounces all of a sudden (and for a long time these words remained obscure to me) the category of form. He leaves the church and collapses on the flagstones. A voice murmurs in his ear: 'Ma l'erba è sempre la stessa . . .'.[11] Then he goes his way. But this time, at random.

What did this doubling mean, this 'passage from I to He', this external scrutiny, brought to bear on my phantasms? First, that the demon had been vanquished, at least for a time. But the temptation had been strong

11 'But the grass is always the same.'—Trans.

enough, and the ordeal brusque enough, and hard enough, for me to feel—or apparently feel—that I must use this moment of respite to try and understand myself. In other words, it was then that I decided to write a book in which the 'traveller' would retrace his path or, rather, would really set out upon it, going where I had not been, and pondering works more attentively than I had done up till then: and thereby revive the illusions that I had not had, so to speak, except in dreams. At the same time I would discover what I did not yet know, the secret of the mechanism triggering my waywardness in the name of the centre, and why I wore my life like a glove turned inside out. A book—still another ambiguity. To recommence the journey in writing at the very moment existence had interrupted it was possibly an attempt to preserve it as much as to analyze and, so, demystify it. But it was equally to cast in the non-temporal medium of writing what wounded my life: the fear that is born of words and finiteness and time. Coming up against this fatality, it seemed to me that I would question myself yet more closely. A book with two levels, rather than an ambiguity. A book in which reason would finish by circumventing dream.

I was further encouraged in this when, a little while after that morning in Arezzo, I had a dream, in the briefest sense of the word, which seemed to represent the end of a phase. I was in an octagonal chapel, and on each wall was

a painted image, emerging out of a confused dialectic of over-drawings and lacunae, of one of the sibyls who prophesied the Incarnation to the world. Although these paintings were ruined, I reverted to my usual reasoning, which argued that the damage was for me a challenge, in that it has stripped an art of its exterior determinants, its finish, and would thus enable me to recover that interior form which the painter, under the strictures of line and colour, had lost sight of. And in the work, finally unsealed from itself, presence might appear, and it depended only upon me. There was also, in the air, a wandering voice, which I could decipher more or less as follows: 'If I efface what I write, as you see, it is because you must read. I am sitting in the last of the three rooms that look on to the garden, you glimpsed part of my dress, you came to me in the summer, a child, anxious to love and to learn, will you have time to decipher me, as I take your head on my knees, as you weep . . .' I looked at the sibyl with her face worn away in the silent chapel; and I knew that outside it was summer, loud with crickets, empty light, the path. My whole life, and my whole task, summed up; but I was not afraid.

Yet I was not ready. The surge I had hoped for happened only in the form of symbols and in an elliptical language I could not elucidate. And what did take shape, as I sensed, was only a fragment—some imp in my unconscious shorted

many circuits and falsified a lot of signs. So in the end I destroyed my notes, and the pages already written. But I did not forget them.

I remember lacking an opening. Despite all my efforts, I could neither write nor imagine it. I knew only that it would have to recount the traveller's origins, and the (still accidental) reasons for his decision to leave. Having taken it, he rose, and left his poor student room. It was dark, 'in a town to the East' (that much was certain), damp and silent.

But the second page began almost at that instant, as if it had been given to me, as if I had seen with my eyes, in another life, the events I am about to recount. I encountered the one destined to be the traveller, on that same night; he was walking (it was as though I was watching over his shoulder) slowly down a very dark alleyway with irregular paving stones divided by coarse grass; this led to the edge of a canal also unlit. I felt then, and I still feel, with a physical immediacy, the thickness of that darkness. Near the canal were houses but they were blacked out and almost invisible; there was nothing except a vague reflected starlight on the standing water. But the traveller was obliged to wait there, without moving, for what I knew would be a very long time, as if hidden forces had to beat their way through a tangle of omissions and useless cogitations. 'I remained for about an hour by the water,' the traveller said,

In back numbers where the photographs are
smaller and greyer . . . (p. 77)

or words to that effect (at times it seemed I would write
the book in the first person, at others not), 'and I felt that
my former journey had reached its end.' Then a door
opened 'in the last house', a patch of light spread towards
the water and on to it a little, crooked, old man appeared
on the threshold, vanished in the darkness, reappeared on
the bank standing in the ray of light. He leaned over a boat,
picked up a basket, disappeared again. He turned to the
house and shut the door with a dull sound. No echo. And
there was the absence of sound in that sound, as if nothing
had happened. Yes, the place was exactly as before, with the

same faint light on the black water, and everything stood once more in its shared, unconscious immobility, in the empty juncture of stone with stone.

And the traveller is left asking: Does the place retain no sign of what took place? Does being efface itself, instant by instant, is it up to me alone to remember? He goes up to the boat, which also seems to be waiting, sunk in its solitude. Longer than he thought, it is, in fact, a small barge, loaded with coal. There are letters on the prow that he cannot make out. Then he remembered that the same pieces of coal had crumbled under his feet in the alley . . . Rewriting this page, the author recalled (which he had not done the first time) those 'Moses baskets' of his childhood, made of wicker, named after God's elected who was abandoned on the river. Even though I am sure of nothing now, I must have known this story, this explanation, from a long time ago, because a phrase haunted me in earlier versions: 'A moi l'Egypte, à mon secours le fleuve,'[12] and when, later on, I saw the great Moses paintings of Poussin, without doubt his most irrational, and most inspired, I felt somehow that in them this same half-crushed coal had been scattered in the grass.—After which, but this time even after the *Traveller*, I saw *Father Time* in a museum. At certain times an old man would come out of a kind of workshop; he raised and lowered a scythe in a huge gesture which should

12 'Egypt is mine, and the river is my help.'—Trans.

have encompassed the space of a minute, but the workings were worn or rusty, and the movement of the scythe was jerky and uneven, stopping suddenly and starting off again slowly; the clock scarcely translated the notion that we are temporal creatures. And yet, riveted as I was to this spectacle, I entertained a different hypothesis. I thought perhaps that the clockmaker had not failed at all, but had had the audacity instead to create an image of real time, such as we dare not conceive it, made up of hesitations (or gaps), ellipses which represent our opportunity lost in advance, an outgrowth of precision which, could we live in them, might be miracles. Alone in the universe with its music we do not hear, this clock might testify to our powers . . . Then the canal swam back into my memory.

Clearly, the image had remained with me, and was readily reawakened, despite my having abandoned the projected book. By contrast, I had forgotten all the notes I had taken for the later chapters as soon as I destroyed them; even as I wrote them, and substituting them for others I had abandoned, I forgot them, page after page, as if, despite my efforts, there was no truth in them. For example, I took great pains to describe the traveller's reflections on the works of art, to fathom and formulate what had been my hypotheses and sketched-out categories. But I retained only the ghost of my former and by now specious cogitations, and words could not fix them. As for my real discoveries,

As I did recently Rosso's *Deposition* in Volterra . . . (p. 77)

enthusiasms, joys—they disappeared, strangely, in the labyrinth of galleries and cloisters visited—as I had not really explained—by the student from the town to the East. Why so, I asked myself sadly? Is he not my representative, made in my image? It was a question of level. Just as what I had really felt could have been expressed, the traveller suddenly increased in size and passed into a cloud. And when I saw him again, he was in another space, in a raised world where the light was fiercer, gestures stylized, events and objects clearly symbolic against the golden background of a society either asleep or absent. The traveller was not to be seen where history or psychology predominate. The efforts I made to get him into a hotel or a station merely ended in their conflagration, leaving nothing but one or two fraught sentences. Meanwhile, I could see spreading out in front of him a mysterious field that reason, guide and limit of my present research, ought certainly to have closed off: it represented—I had no doubt—the crossing of the gap, and the first steps down that specious slope I had forbidden myself.

This is what happened to the traveller. He had crossed central Italy until that critical moment, which I took from my own life, that of 'l'erba sempre la stessa,'[13] and then continued with no definite goal towards the Adriatic. And one evening, he came to Apecchio. I had of course crossed

13 'The grass is always the same.'—Trans.

that village myself, changing buses some twenty years ago, between San Sepolcro and Città di Castello. One or two hours wait, as night closed in over the roofs, intensifying the stony solitude: the indifferent, the forgettable . . . But this very emptiness stirred in me an emotion without recognizable object; and it remained intense for days and days. I had dreamt of going back to Apecchio; and so I did, in spirit. And there it is, Apecchio before me! But today the village seems deserted. There is no one at the wine shop to answer the traveller's call, and the houses are shut up and silent. The traveller wanders about Apecchio as night falls, and later still. He meets nothing but a horse, like him wandering about. 'A piebald horse,' I wrote, and I was fond of those words, which I remember, 'in the street washed by shadows' . . . And then? Well, beyond that clear image of the underworld, of death, of magic at crossroads, came glimpses in broad daylight, and even at one high noon in the heat of summer. I got away from there by means of a stormy night, which the traveller was to have spent in an empty chapel above Apecchio. One is entitled, like the icon painter, to such rapid stereotypes when the absolute draws near.

And in the washed light of early morning, the traveller set out across fields and stones, and walked on at random over the hills, until he came to a great wall in the empty countryside. He follows it, and all around him the horizon

is very low between the stones, and the sky very blue, as it is when the end approaches. An impression of blackness invades him, despite the light, or rather behind it, as if the contours of the world were bent round into the confining thickness of a lens, with tufts of colour falling from the surface of things. He is cold and hungry: the orangery is

Who has drawn closer to the threshold than he? (p. 78)

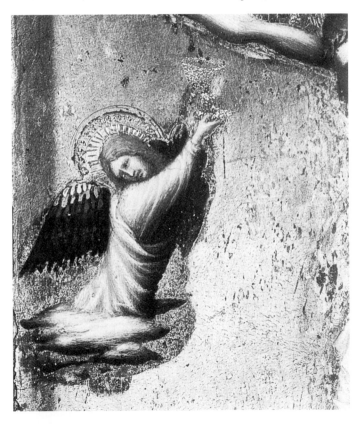

very close. A real orangery! The paradox of a French-style glasshouse on the crest of a hill in southern Tuscany! I know, and only too well, that this must be the end—the metamorphosis—of the book. A long, low glasshouse, with four, big windows open all day long to the sun. I know that this is the place where the traveller, who started out from the bank of a dark river, must end up. And again there is a 'blank', but this time out of plenitude rather than poverty. A tremor of iridescence, of heat, denied me the final vision. And if nothing round me remained scattered, if I was on the rung to a higher transformation, its law remained hidden and I was reduced to making hypotheses. I made several; and, truth be told, I do not know if I could ever have chosen between them.

This was the first hypothesis, or vision, which we might call the *major* one: the exhausted traveller has stumbled on a stone, fallen, and rolled to the bottom of a slope, badly hurt. Where can he drag himself to get help? But there is this low door in the wall; he pushes it and the orangery appears at the edge of the grass. And then he hears a footstep behind him, and hands touch him, and the *guardian of the place* leans over him. Anne, in Leonardo's painting, with Mary, has that smile, on her lowered, half-turned face. But, in his delirium, the last scales fall from appearance and the traveller is blind. His eyes closed, almost unconscious, he feels someone carrying him, where he knows not—and yet

he trusts them fully. In a variant to this ending, the traveller is tended in the glasshouse, and is aware of it, hearing the ceaseless crickets outside. But in another version, it is certain that he entered the enclosure, and went inside, and hearing a footstep behind him he panicked, fled—what face was this, what terror, come to cancel what desire?—fell, and came to. What further fear, or taboo, in me could that symbolic recovery not transgress? I listen, and there are further variants, possibly further images. And, in fact, one night, the traveller had met a stranger in Florence. Much older than he, this stranger seemed to know Italian art (without explaining anything clearly), and apparently took the subject up at the point where the traveller had despaired of understanding further. They had spoken together or, rather, whispered, in Orsanmichele, about that painting, isolated in the middle of the church, but also about the closed attic above it, and of the nature of its emptiness, in the endless winter night. And after this *the other* (but how to imagine him, so elevated, or so advanced?) became attached to the wanderer, and asked after him from time to time. And he gets to Apecchio, where the houses are reopened, and to the orangery, where he speaks to the young woman. The stranger is there on the threshold, looking at the horizon. The air vibrates with resurrection above the dry stone. In the stuff of form and colour that twines and flares like a flame, comes a voice, crying that the long wait is over. But

I shall risk myself no further in this direction, which is too new—or too ancient. For one thing, the glimpse I had became instantly of a density and curvature beyond my capacities of expression, and even beyond those of space, with the woman beginning to divide into the diurnal figure and another, younger one, with slender hands and a short laugh, belonging to the night. For another, I had to recognize that these splittings, these four presences which a fifth hovers round like the air outside, were once again the matter of my 'novel', *L'Ordalie* ('The Ordeal', 1975) that I had written and destroyed three or four years earlier; and these bifurcations, these prismatic decompositions, were certainly irreducible by all psychology, and by all reasonableness, withdrawing like water from the finished writing.

The wounded teacher . . . (p. 82)

IV

It is chiefly because *L'Ordalie* 'came back' in this way that I destroyed what remained—or was sketched out—of my new book. The reappearance of that structure, with its mysterious demands, its inward-looking infinity, its silent autonomy, indicated too clearly what I had given up trying to understand, when it alone—even after the canal, after Apecchio and the orangery—seemed the only legitimate project. I tore up the *Traveller* because I refused a sealed, imaginative discourse in favour of conscious analysis, a condition of moral experience. And yet, perhaps surprisingly, I made no serious effort to gather up the material I then disposed of, applied now, not to any 'town to the

East' but to my own life, past or present; and this was so, even when memories, observations and presentiments were not lacking to compose a coherent piece of thinking. Even the myths taking shape under my pen, embarrassing as they were for the kind of discourse I wanted, drawing on reason and memory, could have become valuable as a kind of radioscopy of desires in play and even, brought into contact with the facts of existence, provide keys or confirmations. One of them, in any case, was obvious. Whatever the meanings—or presences—implied in the networks at the end of the book, the Oedipal element shone brightly; it pointed in a direction at the end of which I would have found, quite unequivocally, the original *arrière-pays*. As it happened, my childhood was divided between two places, and for a long time only one of these seemed to have any value. I pitted one region of France against the other; I loved one and refused the other. And I made a kind of theatre out of this opposition, charging it with as much meaning as I could muster.

On one side was the town where I was born; this was associated with negative experiences that succeeded in structuring my memory. Of Tours before the last war all I recall are the deserted streets, as they really were, in the deepest sense. We lived in a district of small, poor houses. With the men at their workshops, and the women dusting behind half-closed blinds, there was only a child's brief cry

At times so tense, impatient, black, and at others reconciled . . . (p. 82)

to break the silence from time to time. In the little dining room, full of cupboards that were forbidden me, I would stare between the shutter slats at the burning June asphalt, doused in a great wave by the municipal watering cart. I was beginning to be troubled by the fact that numbers are an infinite sequence. And at the evening meal, under the yellow bulb, I tried to find the mysterious point at which the crust ended and the crumb began. But even as I did this, I was anticipating the night that was ahead, the moment of departure for the holidays, that strange, sacred night when, to the regular rhythm of the train, travelling through the invisible countryside, going through a tunnel, or stopping for a minute at the silent platform of a station, I would ask myself something like: Is this where what I am leaving ends, and the new world begins?—Many years later, when I was studying the progression of proofs leading up to the Weierstrass Theorem,[14] which tends to stress the idea of the particle, and of before and after along a straight line, I was suddenly possessed by a kind of exaltation, for no apparent reason, made up of joy and sorrow, and in a flash I saw myself lying along the seat of that train, my face resting in a folded coat, trying to sleep but not sleeping. This obsession with the passage between two regions, two influxes, possessed me in childhood, and has

[14] Karl Weierstrass (1815–97), German mathematician who did much to refine aspects of calculus.—Trans.

done ever since. And also, surely, given that the space is more a mythical than a terrestrial one, it contributed to my articulation of a transcendent.

And there, on the other side, were the images of plenitude. On our arrival next morning, we opened the low door, with its faded paintwork, that gave on to the garden (known as *le parc*, and it's true there were some big trees), between the house and the church, and I ran to the bottom of the orchard which prolonged it to the right, leading towards the light and with a view over the valley. And there the fruits had begun to ripen. The greengages and plums would be falling all month, then the figs, and perhaps the grapes —the plums would split open, sweet offerings to the wandering wasps; and I almost wept with a sense of belonging. Exile was over. Fat and grubby Zénobie, forty-five years old and with the bearing of a queen, would go by, driving her geese before her with a stick, towards the so-called henhouse—an entrance hall, kitchen and sitting room abandoned to clucking and dung—and this was the earth itself, crowned and encircled by fires. And this time a lot comes back to me, the thick grass, the wind, the house, the villages. And yet, just as Tours did not deserve my dislike, I see clearly now that Toirac was only worth what I thought I loved about it; that was already the important thing. I did indeed love that country, and it even influenced my deepest choices later on, with its great empty meadows, with its

grey stone and continuous stormy days above the closed chateaux. But what could I have made of this difficult beauty, if there weren't some other, maybe accidental, quality added to it? When we left in September, with the very first mists, the grapes were usually still ripening; and in this sense it was an endless summer that welcomed us the following year; the valley, the river below, the hills, this was a country out of time, and which had already passed into the dream of safe years, innocent of death. It is the country in which, as Rimbaud said, flesh is a fruit still on the tree; or where Mallarmé's supposedly shallow stream is still hidden in the thick grass. A country, consequently, in which the spirit can understand the universe (in a naive way, to be repressed rapidly) not as the collision of achieved existences but as a music of essences. The 'golden leaves', indeed. In fact, this '*massif* central', tinged like this with the absolute, in many ways resembles the inward country of my later reveries. And when the signs I never wanted to see—an iron bridge beneath poplars, an oil slick, and many others, which embodied nothingness—had encrusted themselves within the primal light, as my age demanded they should, it was only natural for me to think that my dream, detached now from reality, had no alternative but to recede into the horizon.

To add to this, my grandparents died around this time and I remember the second funeral as marking the end of

my childhood. The children learning their catechism were perched on the gravestones to avoid the nettles; they kept repeating the same Latin verse, tirelessly, like trying a locked door, while the busy, indifferent bells tolled on. Throughout all this, I stared at a particular tall tree standing on a hill on the other side of the Lot, with indescribable emotion. While I should have been present and attentive to what was going on in the little cemetery, I was walking over towards it but stopping every few steps, to plunge myself in the absoluteness of its form and in the gaping void around it, and in the stones. Today, I can grasp what this meant to me. Isolated between heaven and earth, in its intense definition, in its existence as a sign without meaning, I could recognize it as an individual like me; and from then on I knew that the human is rooted in the finite. But if from that moment I decided to make of it my *réalité rugueuse* (rugged reality), my 'duty' (yes, this, too, corresponded to my thought, which hardened later on),[15] I did not, despite everything, interrupt my dream, which was simply diverted from the immediate

15 The allusion is to a crucial passage of self-revelation in Arthur Rimbaud's *Une Saison en Enfer* (1873): 'Moi! moi qui me suis dit mage ou ange, dispensé de toute morale, je suis rendu au sol, avec un devoir à chercher, et la réalité rugueuse à étreindre!' (I! I who called myself mage or angel, freed of all morality, I am brought down to earth, in search of a task and a duty, with rugged reality to be embraced!).—Trans.

surroundings, and reformed on the other side, in the image, the lost unity of the relative with the infinite. 'The tree', I later told myself (I thought of it at night, I wanted to see it again), was the first signpost dividing the visible. It existed already as the horizon above Apecchio, and I could easily have evoked the memory of it in my *Traveller*, however obscured by myth.

Until the day came when—given further markers along the way, between here and there—I was to meet with other signs and enjoy a first moment of hope. It was at Tours once more, a place I wanted from then on to make my own, despite recurrent misgivings. I must have been about twelve, because I was learning the rudiments of Latin, which instantly compelled me with its words that matched my own, giving them an unpredictable dimension, imbuing them with possible secrets—but above all by its wonderful, resonant syntax. By using cases and declensions one could dispense with prepositions as links between verbs and substantives. With its ablative absolutes, infinitive constructions and future participles, one could contract into one word, or into a denser structure, like a secondary apprehension, what French could only express by unravelling them. Far from dilution, this density seemed to go straight, and intimately, into making significant relations; and hence to uncover—in a hidden way, certainly—something like an unimagined interiority (as of a substance)

within the fact of words. Of course, I didn't think of it in those terms, and I had no idea of what this depth was, exactly. It was images, rather, that compelled my thought; it seemed to me that Latin was like a thick, dark green foliage, a laurel of the spirit through which I could make out a clearing, or at least the smoke from a fire, the sound of voices, a quivering of red cloth. I was waiting for I knew not what when, one evening, I sat down in front of the slightly yellowed, almost square page, covered in a mixture of italic and roman fonts, which dealt with the grammar of place.

No sooner had I started reading than I was dazzled. The page dissolved within me, so to speak, and the next morning, as the first or only one to be questioned on it, I announced my revelation in a kind of ecstasy that had already gone deep . . . What had I learnt? That to say *where*, there is *ubi*. But this word designates only the place where one is, whereas for the place one has come from there is *unde*, and *quo* for where one is going, and *qua* for by where one will pass. And so there were four dimensions to break up a unity—an opacity—which was thus shown to be factitious. The French *où*, contorted in every direction, contained within it undreamt-of spaces. And at the same time, the dismal '*où*', the place of enigmas, opened out into a memory, a future, a form of knowledge. It was rather like the moment when, used to the simple idea of

Without doubt his most irrational, and most inspired . . . (p. 88)

This same half-crushed coal had been scattered in the grass (p. 88).

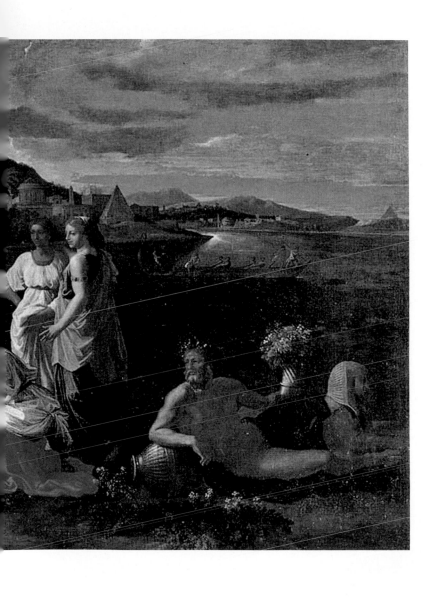

a curving line, one discovers the notions of root and integer. And just as these moments occur in geometry and algebra on the horizon of problems they do more to create than to solve, by dissolving the basic field into a vaster structure, I hoped that Latin, as a more sensitive instrument, like the algebra for an alienated discourse, would enable me to understand why I felt lost and where I should start looking. In smaller print, at the bottom of the page, it was noted that with the verb *ire* (what a verb, surely the profoundest of all!) the place one is going to can once again be designated, without the preposition, by simply using the accusative. *Eo Romam*—to Rome! What an admirable transitivity, and how substantial feels the link between movement and destination! And what proof of the power of language. These two words alone seemed to me like a promise.

And so I began to read Virgil; from which the example was taken, and other poets whose syntax remained obscure; I felt something like dread in front of these vestiges of a superior, and more capacious, consciousness which little by little was to reveal its arcana to me. But I have to recognize, now, that my intentions were ambiguous. I realized quickly enough, or rather part of me also knew there was nothing left to discover in these forms and works, which were, in fact, categories and modes of being, except what every grown-up, or at least every poet in any

language, knew already. But it suited my purpose to keep the illusion alive, enabling me to sketch out my grand dream. What appeared, in effect, with the Latin language itself, was the mysterious country that had used its words. And since Virgil's shepherds are almost divine, accomplishing their destinies in a way that approaches music, burning time within space like those grass fires in autumn that enlarge the sky; since they inhabit a country of high pastures, forests, in the very heart of the Italian peninsular, everything together could imbue itself with being in my eyes and guarantee the survival of its mystery even against the wider knowledge I would acquire. Being attracted to a language, in fact, steered me towards another horizon, and another country. And when I had to get used to the idea that Virgil or Lucretius or even old Ennius had betrayed the promise of *Eo Romam*, this second country survived the disappointment and enabled me to compensate for it.

I already 'reasoned' this out with myself. Virgil had not spoken deeply enough, or as *unfamiliarly* as Latin seemed to allow. He even let himself be lured into an illusory elsewhere, in the mountains of Greece, before dying in that 'passing place' to which he returned, Brindisi. But was it not simply that he lived in an age when the secret had got lost? And was it not necessary to go further behind this moment of poetry, which was just a vestige, a first line of hills, to a more ancient state of the language, perhaps

Anne, with Mary, has that smile, on her lowered, half-turned face (p. 94).

all the way back to those dialects which preceded Latin, back into the woods and valleys of neighbouring regions? A marvellous hypothesis! The more Latin disappointed me, the more prestigious became the roads leading to Rome, but this time for their own sake. Another centre had existed. That elsewhere still existed on earth, and it showed itself for the first time as such, having broken with the visible. And as I, too, was verging on the unverifiable, the dream could freshen, and it never ceased to return to me on light breezes or gusts. One day, much later—I had visited Florence by then—I was reading Alfred Jarry's

admirable *Descendit ad Infernos* (1950), in which he quotes a line from Ovid's *Fasti*, and I could measure for myself its efficient durability. The few words are 'Amne perenne latens Anna Perenna vocor';[16] it is true the line has a magic, which in part explains my astonishment, and my attraction, and why from memory, nearly twenty years later now, I can repeat it with the same insistence. But more even than the endless games of depth played between the river, oblivion, eternity and speech, and the goddess, so little known, who melts them in her inapprehensible name, mingled with the waters of the Tiber in springtime, what really touches me is to see this river confirmed in its essence upstream of Rome. And how, again, an obscure back-country can lay claim to primacy over the simple visible centre.

A back-country which would be situated, in fact, not far from Apecchio . . . In fact, when I had to wait for an hour or two in that village, I might well have been moved, even for no apparent reason, or precisely because of it: for Apecchio was then, in its very essence, *the place one passes through*, but in that fabulous region where you pass almost through the centre although you cannot see it. I might well be troubled (a better word for it) and I would have understood why, and I should have, so I thought, written it down, to tear the real away from the eddies of memory,

16 'Captive of an eternal river my name is Anna Perenna'.—Trans.

the illusions of desire, and to fix at the centre of my thought the fact that the fifth question in the structure of four—the one that cannot be situated but equally the only one to which there is a reply—is that which fathoms time and not space. But I said then: 'Vorrei e non vorrei'—I would and I would not—and something in me balked at the task.

In its intense definition, in its existence as a sign without meaning . . . (p. 103)

Of course I reproached myself. What was the good of having confronted the fact of finiteness, read Baudelaire, Rimbaud, Shestov, and chosen as epigraph for a book some words on the life of the spirit and on death that I knew to be the truth of poetry, as of all significant existence, if it were only to fall back if not into the first dream

(because Florence, with her scruples, had saved me from that) then at least in to the unceasing yearning for the dream which still had the power to inhibit me? And since I could put an end to it if I wanted, why then did I not; was it not because at its core I found this ambiguity suited me, and indeed was my own truth? These were my blackest times. I wrote poems in which I let myself be reproached by voices which came from my moral conscience, accusing me of being afraid, of letting the fire—inasmuch as it had ever caught—go out on the table where I sought presence, choosing rather an uneasy sleep that drowned everything in murky water; and the chosen epigraph, the new epigraph, which was almost a denunciation of the first, also addressed me severely, even menacingly, under an illusion that seemed linked to my own—Hölderlin's obsession with Greece. In fact, what I remarked in myself, and what I thought I could identify and judge, was the primacy I accorded to the beauty of a work over lived experience. I reasoned correctly that such a choice, by delivering words up to themselves, and creating a language out of them, created a universe that granted *everything* to the poet; except that such a universe, cut off from the changes of each day, from time, and from other people, would lead to nothing, in fact, but solitude. Once having made this judgement, I concluded shortly that the greatest suspicion should be cast upon any poetry that was not—owing to

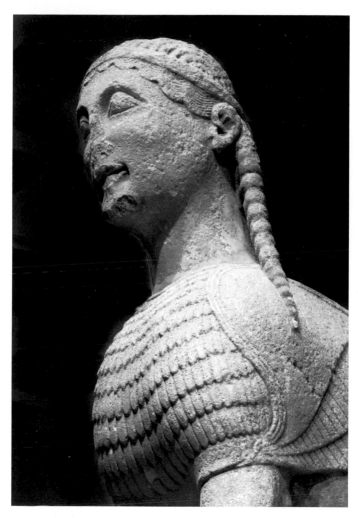

And, as before, its eyes astounded me (p. 123).

the need for closure, or form—expressly negative, or at least so cruelly aware of time's dominion that it remained constantly on the brink of silence.

Everything seemed simple then, and coordinated; in those moments I did not pursue my thought to its conclusion, and when I reproached myself for not so doing, the coordination was that between my anxieties, my self-accusations and my writings. Say the memory of the 'Red Sands' returned; I immediately 'understood' the reason behind my interest for the book. Of course! I could not accept that Rome, an existence, should perish. And I charmed myself with the idea that where death seemed to have triumphed, existence was perpetuated. But most revealingly, this survival took place in the desert, since, far from conquering death, as should happen, through the depth of lived experience, and by a kind of faith, I could only imagine its death as remote, in the solitude of the dream and with the vain freedom of words. It was then that the last page was illumined for me, the page that had so moved me when young but which I had not understood. I should explain that the story did not end where I left it, with the final retreat, and resurrection, of the city in those transcendent sands. In love (helplessly), and sorrowing (unto death), the young archaeologist decides to go home to France; we meet him again on a train in Central Asia, at some stop, God knows where. There's a crowd of

people on the platform, shouting, calling, jostling, hawking their wares—he looks at them distractedly, but suddenly! It was her, the girl, just there, moving away in the crowd; the very girl who had fled along the underground galleries into the desert. He leaps on to the platform and runs, nearly catching up with her, but she turns the corner of the station building; and there, on the other side, more peasants, animals, baskets and baggage, but of the young Roman no sign, though he goes crying and calling through the crowds. 'Une seconde fois perdue!' In fact, for the third time, as a repetition of the first, but this time irreparably. I, too, wept at this cruel ending. And I invented many hypotheses to explain this extraordinary meeting, and why destiny should be so unjust. For a long time I waited for a sequel which would have repaired this unhappiness; but all the time I knew that it would never come.

But there was no need now to wait for anything; I understood, I knew. Inexplicable, certainly, in a narrative sense, and unjustifiable in the light of a surface psychology or a naive moral, on the ontological plane this ending was only too natural; it was even inevitable since it opened up the fault that gave the book its meaning, and denounced the fault inherent in all writing. 'Lost' once more then (in truth, for the first time in the light of day), the young girl who had only ever been glimpsed, and who had spoken briefly, in her dead language, from the bosom of a world

both unforeseen and known in advance, separated from life, and even from space, by a hiatus of darkness—or was she? No, not at all, for she had never existed, not for one moment. For the archaeologist himself, that Rome had only been a splendid dream. The proof lies in that interdiction, expressed in deep language, symbolic of origins, on his going any further. And, in fact, there is nothing more ambiguous than this warning, because it could only broadcast what it was meant to conceal, and carry within it all the future events like a seed carries the plant. And it was that moment in the dream when, once stopped, we move forward again, already knowing what we are unaware of—and we pretend to brave a 'mysterious frontier' because, in fact, we want to escape the constraints of another, that which urges knowledge of its own finitude on the spirit. The two enigmas of the book are not in succession, but superimposed one on the other, and in this way, in fact, get dissipated. In an ordinary existence, standing at the edge of time, as it flows away, with its lost opportunities, and its strokes of luck, its miraculous escapes from the scythe, the boy has spied some girl he 'could have' loved, but that would have been to choose, to commit himself to incarnation, to death itself; he preferred to 'abolish' (to use Mallarmé's language again) that existence, refusing to admit the limits and contradictions that would have belonged to him, in order to recompose its essence in an order of

infinity, out of time. In so doing, he thought to release her from nothingness: Did he not make a queen of her? But she would belong to a world without substance, and without future; and he was only using her for his reverie and for his work, which is how she disappeared, through the fault in his writing, at any rate out of his life, which was form not destiny. All and nothing. And yet again the cruel dialectic of aesthetic creation comes into play, emptying a life of its every moment, to leave the precious shell, holding the sound of who knows what invisible sea. And my admiration for the author of the 'Red Sands' was reinforced, in that he had used Latin as the language of origin, but also as that whereby literary language should become distinct from everyday speech. How this little book suited me! Almost as though I had dreamt that up as well.

And what if we ourselves are dreamt up through the books we read? At least, if we have to wake up from some of them to understand life better, and primarily the script at the heart of it, more dialectical and generous, possibly, than any books which may or may not have usurped it? I understood, I knew . . . And yet! There was something else, in complete opposition, that I had to understand, and soon—which dated from the last poems in the book I mentioned, and a return to Italy that I shall now describe —and which I had begun to learn. An obscure approach,

on which I got lost several times, and which even today I have not completed, perhaps never shall—that is, at least, for anyone who looks beyond a simple condition of self-acceptance (in its strengths and limitations) as our natural resource.

I was returning from Greece by boat, due to arrive in Venice the next morning. Greece, with its rectangular temples, always subordinate to the great physical masses of the site, spoke to me of simple harmony again—born of limitation but of immediacy as well—with existence here; but the effect faded, and it became an image again, while Italy, that land of images, increasingly occupied my thought. In this divided state, I spent the night writing. One memory haunted me, which seemed to concern this contradiction and my need to overcome it. In the little museum at Delphi I saw the Sphinx of Naxos and, as before, its eyes astounded me. They are wide open, in a joyous anticipation of the stirrings of knowledge. But with the passage of centuries, and frosts after rains, the marble has eroded; the upper eyelid, which formed the merest rim to the globe of the eye, has practically disappeared. It is almost as though the Sphinx had closed its eyes; and as it is still smiling, that it had turned to contemplate an interior image. What does the Sphinx see? Stable form or infinite metamorphosis? Or does it not blend them in one vision, a single, absolute gaze? But this question instantly seems to beg another. Erosion adds so much to the work that it is hard not to believe the sculptor never took it into account. He knew

that sculptures finish up in dusty fields, and he drew that thin line just over the empty orb so time would efface it, and a shepherd might come to meditate on it. But could he have used his time thus, without once reflecting upon his being, his demands, even on his capacities? And was it not the latter he had indicated in the sole element of the work he permitted time to work upon? Then I imagined that the Sphinx represented an equation in which one side, constituted of spatial mastery, wisdom and intelligible beauty, would be balanced on the other by, what else, the *unknown* quantity. And once again, my clumsy, pressing need for coherent thought propelled my pen which made pages and pages of notes.

But perhaps I had gazed too long, that afternoon and evening, at the foam breaking against the prow, the straits open up and close again behind us, the islands disappear, the sky propel its clouds; perhaps it was the constant sound of the engine, and the water lapping which invaded the cabin. In any case, I multiplied my notes and crossings out, finding nothing, but not really rejecting anything (which would have been the solution), when I climbed up to the bridge to watch the lights of Brindisi. I hoped to see some boats in the port, some warehouses, the massive Duomo all lit up. And yet my thoughts had darkened again. I recalled that Brindisi was where Virgil died, leaving his poem unfinished. And what was I, what had I done,

that evening? I was alone on the sea, with the noise of the engine—persistent as the passage of time itself—with my memories of the Delphic flagstones, and with Italy all before me—my whole condition summarized. And, suddenly, the shoreline the boat was now following in the dawn light seemed to me very menacing. I understood that this was the labyrinth in which, lured on by that enigmatic beauty, attracted like the birds of Zeuxis[17] into the flat image, I should end by getting lost—as I had intended. My slow journey into Venice that evening seemed to confirm my fears. Although there was sunlight, the sky was black, and the sea opaque, of a pale absinthe green; and there I was, imagining that the low islands, the buildings, the churches, even those of Palladio, were but the negative, worked over by countless iridescences, of an inconceivable, positive image which would only be revealed in its fullness, for example, in another room.

I disembarked, nevertheless, at a real city; the proof being the posters and banners announcing an exhibition of paintings. What is more, it was one of those rare retrospectives I would not have wanted to find at Venice, of 'Crivelli e i Crivelleschi', Carlo Crivelli and his school. I

17 Zeuxis (464–398 BC) was the Greek painter who, according to legend, painted some grapes with such realism that birds came to peck at them. There are frequent references to him and his legend in Bonnefoy's work, as a symbol of the 'lure' of images.—Trans.

A marvellous late afternoon warmth (p. 132).

did not especially like his paintings, or the ones I had seen
by him, in London for the most part. I rejected Crivelli
simply because of his mediocrity. I did not exactly hate
that kind of black rim with which he weights his faces, an
over-rich *fin-de-siècle* frame for their autumnal colour.
Examining the poster, I was aware that if someone were
to describe these tall Madonnas to me, both hieratic and
childlike, and at times vaguely perverse; if they added that
this decorative work, for such it really is, was shot through
with echoes of Andrea Mantegna or Giovanni Bellini; that

they were painted in different cities along the Adriatic coast, in that mysterious region between Ancona and Macerata; if one regaled me with such marvels, even holding back a little because of the black rim, I would be seized with enthusiasm and hope and throw myself into the trap. I did, finally, visit the exhibition, pursuing these rather ironic reflections; and I did not change my mind about Crivelli, because mediocrity pure and simple exists. It was rather like a rendezvous at which the other person fails to appear. And little by little you realize that you never met this person, you know nothing of him, he may not even exist—the rendezvous remaining the only fact . . . Rather futile thoughts, when, all of a sudden, my attention was caught by an altarpiece, or possibly its predella.

I consulted the catalogue, and found that it was by one of the Crivelleschi; in this case, a little known artisan, credited with uncertain attributions. But the quality of the painting seemed to me superior to the master's. The mournful shaping had gone, and the colour, so far as I remember, was more transparent and lighter. But what really caught my attention was less these aspects than a face which had a singular expression. There, among the other saints clustered around the Madonna and Child, was a younger, rather angelic figure (I no longer know which, looking at the photograph now, ten years later). Was it really a smile—that ironic flicker that seemed to cross its

face? In fact, the image was small, and damaged; it would have been better not to attribute too much weight to it. But I was in Italy; my demon was aroused, and tempted me in my ear to turn imprecision on its head and make plenitude out of lacunae. Then I had an idea. This face, I reasoned, expresses by its smile (which is not a smile) *an unknown feeling.* Not a feeling that the faults in the image had disguised from us (there were none) but a way of being that would be as important as faith and hope, but which escapes us, and must escape us, because the categories of our consciousness, or of those societies in the past whose histories we know, have no connection whatsoever, and share no frontier, with what has been . . . The direction my imagination took is recognizable by now, and nothing new (though, on earlier occasions, I would not have dared identify an otherworldly sign so promptly); and normally I should have felt, undergoing the process yet again, some lassitude. But this was not so, and a kind of lightheartedness, made up of hope, a feeling I had never experienced before, awoke in me; and I knew it was deep and lasting.

But now I must make one clarification; the notion of the 'unknown feeling' had not, this time, come to me like those earlier, similar chimeras—directly into my line of existence; as a dream, undoubtedly, but combined with the idea of taking it seriously, and of living by it on the most personal level. No, the context now was no longer

No, because it operates beyond words (p. 135).

my life at that present moment but, rather, a structure as wholly imaginary as the first idea when it occurred, albeit less developed and clearly still incomplete; it was, in fact, a sketch, a plan even, for a story. An unknown feeling, a spiritual variant, existent when this Lorenzo Alessandro was painting but now impenetrable; a feeling that had traversed the obscure region around San Severino in the Marches (almost next door, coincidentally, to Camerino). Yes, but why not a historian of the Quattrocento who, one day . . . No, for it would not be exactly the same painting. I would describe, exercising my storyteller's right, a work harder to attribute, or even to localize —originating maybe from Umbria or the Marches or southern Tuscany, for all of them contributed to the first great works in perspective. The altarpiece had been long forgotten. It was gathering dust in an attic or a sacristy; then it had been recovered, sold, before it disappeared again into an American collection; but a photograph had been taken and published in the *Burlington Magazine*. And the historian . . .

Well, it seemed then as though three (or four) lamps, arranged in series in an underground gallery, had suddenly lit up, and lit each other up in turn; I was seated on one of the benches in the exhibition, and then in the Ducal Palace, taking notes. The first idea, simultaneous with the first glimpse—the historian has seen the photo in the

Burlington, and becomes convinced that the face portrays an unknown feeling. To make his discovery known, and to solicit help, in the form of other photographs or archival material, or to invite suggestions for a more precise attribution, he publishes an article in a review and destroys his credibility in the process. He was dismissed, as he obviously would be, as a crank.

But one morning—and we have got to the second lamp, the gallery looks larger and there is more daylight—the historian finds among his letters *the reply.* A linguist has written to him. Sir, he writes, I happened to read your article, which I found both disturbing and reassuring. For many years I have studied the dialects of pre-Roman Italy. Little by little, by arranging fragments and by comparison with the earliest Latin, with Greek, with the little Etruscan that has come down to us, the Oscan, the Paclignian or the March; by studying myths in which, sometimes, there is a fault-line, or a slight projection, as if the two sides of absence had been patched together; by serious study of the Iguvine Tables and fragments of poems, even late ones; by situating certain words, utterly untranslatable, that fit no known semantic structures, I, too, have come to the conclusion that there did indeed exist, in the Umbrian dialect that was spoken in the region you describe, obviously long before your painter was working—an unknown feeling. We must meet as soon as possible. Together . . .

the historian reads no further but starts out immediately. The linguist receives him, far from Paris, in his lovely, peaceful house where he begins to expound his theories, his reconstructions, almost his proofs.

By now I am still scribbling, though more slowly, on the cover and in the margins of my inadequate notebook, by the light of the third lamp which is soft but intense; the vaultings have almost dissolved in the bright daylight. The linguist is seated behind his big table. There are four windows in his library, which the bookshelves divide into three, and a marvellous late afternoon warmth, no, it is suspended forever, in a garden full of coloured birds and leaves. The linguist talks and talks, and the historian listens to his hypotheses, shares his assumptions and almost understands his proofs. Someone shares his intuition, and that is already a consolation. Could it be true that an unknown feeling exists? Now that there are words to clothe it, if not to understand, will his doubt come to an end? But why must it be that at this very moment the historian, if such he be, must nuance his concentration with irony, and draw back from the *other side* of the spirit to that system of thought —or of words—which, revealing it, distances it: or, by describing it, replaces it? It is a strange commitment he must find in himself, at once intimate and distant, trusting and incredulous! It is as though he were looking at a painting which was executed according to the laws of perspective,

but from the wrong position, neither in front of it nor on the same level, where the studied effects would be lost in the depth that is glimpsed. He cannot enter wholly into the illusion, therefore, but he can hear the music of those numerical scales, and that is enough to appease him. And what astonishment follows! And his exaltation rises again, issuing from the broken vase of his illusion (he feels it, breathes it), which he would never have suspected, the depth of the instant as it comes, the quality of choice to be made, the wonder of existing within it. How to express this, when I scarcely understand it? Think of the wide roads, easily visible on the sides of a mountain; from a distance they seem to speak to us, they are a guarantee of the sign they trace under the clouds, a fixed sign that is quite mysterious in the movement of sky and things. But the closer to them we get, they flatten out, under the wheels of the car, become a straight line, and fall away from the annihilated sign, from that enigma; and yet a form continues to exist but now it is behind us, above, around, in the distances where nothing further accumulates but the facts of our passage, a crest from which nothing more flows than the eternity of that instant. And that is a source of great joy.

The historian now knows for certain that he has been written off by the readers of the *Burlington Magazine*. But instead of feeling regret, distress or a facile self-contempt,

That would be the crucible in which the *arrière-pays*, having dissolved, would re-form . . . (p. 139)

he jumps up, his face full of laughter, and holds out his hand. Thank you, he says, I shall think about all this. Thank you, says the historian (but was he ever a historian?) for looking at this image. Ah, yes, says the linguist. I had forgotten about it. An unknown feeling? Perhaps you are right. But what strikes me most forcibly, the more I look at it, is how ordinary it is. Why did you choose it, rather than those around it in the altarpiece? Why not the Virgin herself? Because she looks rather like you (yes, though younger of course)? In fact, I have often thought that

any face at all in painting could pass as the expression of an unknown feeling. Leonardo's Saint Anne, for example, —what is behind her smile? Oh, believe me, it is not so simple. We are surrounded, doubled . . . Thank you, says the historian. He is on the threshold, now, gazing at the light. And his new joy grows fiercer by the instant. Does he wonder what it really is, what it wants? No, because it operates beyond words. As though he felt—dare I write it?—a feeling he would never be able to decipher.

I do not know if I would have dared, because a few hours later I had already given up the idea of writing the story. But all afternoon and evening, in the train to Mantua, I contrived to fill the blanks left in the sketch I had made that morning, because I wanted to produce a text, and the details came to me, as though I really should prolong the experience. The title was obvious. As for describing the works involved, I had an abundance of material, and I believed I could express through the oblique approach of fiction what I had never yet dreamt of being able to convey of my strange, and yet intimate, knowledge of Quattrocento painting. The linguist's arguments did not put me off either (this time thanks to my own ignorance, because I was unaware how little is known of ancient Italian dialects). I would simply have to put myself to school, and I thought with pleasure of the vast technical tomes that delved into the question of location

and the origin of some or other irregular verb; Ernout and Meillet[18] would certainly enlighten me on some Etruscan derivations. But things got complicated when I tried to construct the historian. How old was he, where did he live? These seemed to be secondary questions, demanding brief answers; the only function they had was to provide the sketchy decor to contain what I considered the real protagonists, word and image. But far from resolving the question in a few bold strokes, I found myself groping among incongruous details and idle speculations. Did the historian take night trains to the south when he was a child? Did he not have a daughter? And had he not gone to Vierzon, one snowy night, to give a talk on the unknown feeling (there were other themes but less insistent). Then I heard a voice rising out of that snowy cold. The historian finishes his talk when a student approaches him. *My name is nobody*, he tells him, and they wander off together through the crowd, deep in talk. Etc. There were pages and pages of this. If the business was complex, and even contradictory, its origin rapidly became obvious. The historian was myself, my past and potential, and everything seen and unseen writhed violently together in a bed of eels. The story would take up an entire book. To the major theme, given over to the intransitive, and to silence,

18 Refernce to Alfred Ernout and Antoine Meillet, *Dictionnaire Etymologique De La Langue Latine: Histoire Des Mots* (Paris: Klincksieck, 2001[1932]).

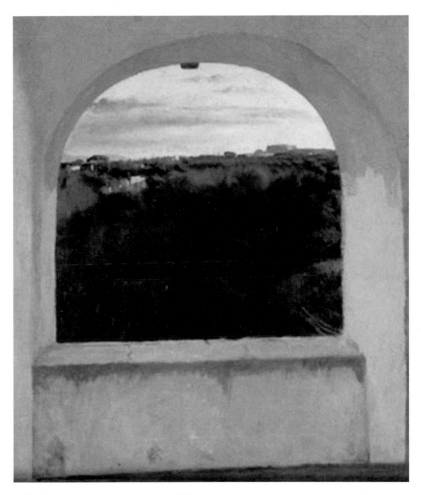

Of a metropolis, *over there* . . . (p. 141)

I would have to join a thousand strands of analysis and memory, and range patiently over the depths within me. Would I not have to justify that instant of intuition I had, looking at the photograph, by referring to those months of entranced wandering through Italy; by describing, who knows, even the *Traveller*? Now I had been solicited, I had to respond. Constrained to be simple, I would have to bring to it the infinite fruits of an existence. The exaltation of those first hours changed then, in this second night train, into perplexity and anxiety.

But suddenly, on an impulse, I tore up the second notebook and instantaneously, even as the train slowed down and stopped, I felt not exactly a primary joy but the stirrings of an intelligence that cast a clearer light, a more diurnal light perhaps, on my attitude to the principle of poetry. To use another image, it was as though I closed my eyes on this continuous, significant, paralyzing text that I imagined writing, and opening them again, immediately, on to a light beyond, still vacant, but in which I could make out the lineaments of trees, birds, real horizons—a whole world, in fact. No, I told myself, I would not write *An Unknown Feeling*. And if I think about it tomorrow, I shall still refuse to do so. For it would be to betray the pointer itself that had been granted me; and I know that, despite my demon, I am incapable of doing that. The earth *is*, and the word *presence* has a meaning. The dream

exists, too, but not to destroy or devastate them, as I had thought in my hours of doubt or pride: as long as I could dissipate the dream itself, without having written it, but lived it: for once it recognizes itself to be a dream, it is simplified, and the earth gradually returns. It is in my own becoming, that I can keep open—and not in a closed text—this vision, this intimate knowledge; it is there, it can take root and flourish and bear fruit if, as I think, it has meaning for me. That would be the crucible in which the *arrière-pays*, having dissolved, would re-form, and where the empty here and now would crystallize. And where a few words would shine, possibly, and while being simple and transparent—like that emptiness, language— would yet be everything, and real.

I had, in fact, decided on the third epigraph, which three years later I placed at the top of a new poem, on what dies, on what is born, and on the passage from one to the other.—I want to add only one further remark before closing this chapter whose starting point, or initial metaphor, was Italian painting. However my own future has unfolded since that day (and I badly need to analyze the difficulties and regressions of that future),[19] it did mark an end, in that the haunting obsession whose return I was

19 For Bonnefoy's later considerations, see the three recent texts included in this volume, especially his 'September 2004'.—Trans.

afraid of between Greece and Venice almost disappeared from my thought. The next day, in Mantua, where the Mantegna exhibition had begun, I heard the solemn message *clearly*, and with some others, Piero, Bellini, Giorgione, echoing it in the distance, expanding by their conjoined visions the place of exchange whereby, born of the blood of silence, we have access to the real. It is also within this 'Holy Argument', which deepened and widened, that a voice arose, increasing in volume—one that I had up until then, if not exactly obscured, then at least misheard, though it was far more alert than any other to the question that obsesses me. *Formerly*, when I looked at the great Baroque churches, I understood the intention behind them, but accepted it with ambiguous feelings. The Baroque, in transubstantiated form, loves what is limited, what passes: what else did I want, and so I gave myself over to this view of things, the most direct and compassionate that an art has ever offered anyone who approaches it. At the summit of its will to transmute nothingness, there is an assumption of place, certainly not for its virtuality as the centre but as earth nevertheless, the ordinary earth that is here; and at the time of the *Traveller* it flew in the teeth of my postulation that another place existed. How can one consent entirely to the absolute on Roman soil when one is dreaming of that wellspring where pure being accumulates? Why this cry of triumph since here,

where the cry was uttered, the gold does not shine in the vessel, however irradiated the latter may be in the horizons of Claude or Poussin? And so I guarded my hoard of squat columns, broken pediments and heavy statues against the sky, for my second dream, with no holds barred, of a metropolis, *over there*, (in the desert, on high mountains, or on the stormy shores of some inland sea); and as I was looking, more concretely, in the small confines of Italy, for a minor hinterland, reduced to a ridge of earth, a nuance in the light, a peeling painting at the end of a vault, I did not linger in St Agnes' or St Peter's, nor even in Rome, though I vowed not to forget the silhouette of Sant'Ivo alla Sapienza against the clouds.

The day did come, however, as I have said, when, the obsession lifting, Italian art appeared to me in its true nature, which contained, in one of its moments, my 'folly', but confronted now, and sometimes surpassed. And soon it was the Baroque, the Roman Baroque, which arose bearing the mystery in its hands, and this time in full daylight, of an assumed place of existence. In fact, it was Rome, as much as Greece, which prepared me for that morning in Venice. The first proposed the subordination of the human position, as of the home of the gods them-selves, to the curve, the sole absolute, of the earth. As for Gian Lorenzo Bernini's architecture, it managed to express to me how the *spirit of place*, which is all we have, is forged

out of nothing, by an act of faith, which is like a dream one has lived through so intensely that it almost becomes incarnate . . . So I halted with seventeenth-century Rome, as the very theatre of presence. Francesco Borromini, the Gnostic, and frequently my familiar (when I contemplate that other road, at the crossroads), closes the dream back upon himself, and loses himself in the labyrinth. Bernini, on the other hand, opens it out, and brings forth life by accepting and assimilating this desire. And Poussin, who contains within himself all the postulations, and all the conflicts, to produce all the reconciliations, recoveries, even miracles in a last act of the Universe, and of the mind— Poussin searches long for the key to a 'music of knowledge', to a return to the wellspring of the real by the power of number; but he is also the man who gathers a handful of earth and says Rome is that. He walks along the Tiber, in spring, when the waters are in flood, glinting in depth and blackness; and as there are washerwomen there, one of whom has bathed her child and holds him high in her arms, her eyes glittering as well—Poussin watches, understands and decides to paint—master of the golden bough if ever there were one—his great series of *Moses Saved from the Waters*.

HIC·QVEM
CRETICVS
EDIT·DED.
LVS·EST
LABERIN
HVS·DE·9
Ↄ·NVLLV
S·VADE
E·QVIVI
ↃVI·FV
INTVS·
NI·TIES
VS·ERA
IS·ACVIV
E·STAV
NIↃ·N·

Returns to the Arrière-pays:
Three Recent Texts

Afterword:
September 2004[1]

I

The Arrière-pays figures a mythical expanse, very hard to place, whose furthest limits extend to the sands of Central Asia or the urban wastelands of the Far East, abandoned to broken panes and scrap iron rusting in the grass. But just as the Platonic philosopher possesses of simple immediate reality a paradigm that renders it intelligible, in which its various parts reveal the links that unify them, so the space covered in my impressions that extend from India to America is overlooked by a high escarpment, made up of the multitude of tracks which for many years the Italian peninsula tempted me to take, bristling with its lost languages, teeming with monuments and artworks, all speaking in the clear but impenetrable language that recalled me to an origin which might have been the place I sought, my true place, on this strange earth of ours, so prompt to satisfy my desires and yet so mysteriously disappointing.

1 Yves Bonnefoy wrote this afterword for the Italian translation of *L'Arrière-pays*, later appended to the new French edition (Paris: Gallimard, 2005). It is presented here in a slightly abridged form.

From the outcrop of Capraia, to the twilit distance of roads leading to Apecchio or Camerino, from the mausoleum of Galla Placidia to Sant'Ivo alla Sapienza, along the high walls of Orsanmichele but also in the faint noise of the subterranean water at San Clemente; and also, from the earliest days, some sublime lines of Dante—'ma come i gru van cantando lor lai . . .'[2] followed, more recently, by others no less impactful by Giacomo Leopardi—Italy was for me, in my lived or imagined life, an entire labyrinth of snares as much as lessons in wisdom, a whole network of signs of mysterious promise that I shall not repeat in these few pages, since I do not want to trespass on the matter of my book. I shall limit myself to returning to some words I wrote earlier—in 1959, twelve years or so before *The Arrière-pays* was written—in a poem called 'Devotion',[3] and expand a little on what I meant by it.

II

'To my dwelling in Urbino, between number and the night,' I wrote in 'Devotion', as one might inscribe an envelope containing a gift, in sign of gratitude: it is an allusion, among others, to places, frequently on Italian

2 'And like the cranes flying off, singing their lays . . .' (Dante, *Inferno* 5.5.46).—Trans.

3 Bonnefoy's poem 'Dévotion' was first published in *L'Improbable*.—Trans.

Into the service of the fantastic, the unreal, the dream . . . (p. 153)

soil—like Santa Marta d'Agliè, or 'the winter oltr'Arno'—which were of equal significance in my life.

As for my 'dwelling in Urbino', it is, in fact, a metaphor since I have never had the opportunity to linger even briefly in the environs of the superb palace where the *Flagellation of Christ* and the *Profanation of the Host* face each other or, more exactly, where they confront each other. But metaphors are designed to reveal what escapes us in our ordinary conceptual thinking, and this one says a great deal about my relations with Italy.

The idea of the night, to begin with. I am certainly not one of those who see in Italy, the 'happy land' where laughing hills and beautiful shorelines seem to go together effortlessly with a thoroughly refined *art de vivre* that is both real and worth pondering. Those stones in the sun, dislodged along the *strada bianca*;[4] I know that obscurely, below them, persists sources of the irrational, phantasms, magic: *il buio*, that darkness, which conceals a whole peninsula history, Etruscan, then Roman, and their traditions which, thanks to local customs (scarcely touched by Christianity), persist in the harsh stony lands; a darkness that has never been so fully repressed in the Italian unconscious as the Gallic or pre-Celtic traditions have in France.

4 The white road. This expression refers to the network of unpaved minor roads that run among the vineyards and olive groves of the Tuscan countryside.—Trans.

Terrors of the most archaic kind, the most fleeting of visions, and cries in the night, even at midday: am I mistaken in sensing them everywhere in the Italian imagination? And Uccello, painting his *Profanation of the Host,* seems very exactly to represent this *dark side* of existence —that side of the mind where those beings, the *peregrinantes in noctem,*[5] multiply, and where, in deserted rooms in front of doors flung wide, bizarre chants are sung to ward off demons and salt thrown superstitiously over the shoulder.

But at the very heart of what I call the night, something that has always struck me, and intrigued me, is the significance of number in Italian art, the study of just proportion between the different parts of a building—or in painting, the tracing of an arm or a face—which seems, like an aerostat, to extract form and rise above its attachments in matter, and thereby deliver the mind from the malady that stagnates, it has sometimes been said, in some of the most sanguine aspects of life. I have experienced this euphoric feeling of elevation and deliverance in many places, since I first set foot in Italy, when in 1950, emerging from Florence railway station I saw, rising up before me—darkness was already falling—the illuminated campanile of Santa Maria Novella. Here were numbers tightly organized, creating a

5 Wanderers in the night.

lightness, soon to pass into the invisible—what instant recognition this was, and what hope it generated! From that moment on, I felt I was on the right track.

And yet, what can such hope be worth, beyond the emotion that makes it credible? And the tension existing between numbers, this *simmetria*, is it really the ladder that will allow us to climb out of the darkness, is it the filter that can clarify the gaze that has looked on teeming phantasm? The truth is that numbers are also part of our dreams, they can only transmit an impression of beauty by linking up with memories or desires that, in fact, sustain in us our drives that are mostly carnal; and though their harmonies may well reach out, clarify and change into an elegance that seems spiritual in nature, secretly they remain in contact with what is being played out in our unconscious, in the obstacles of daily life which has its own distracting dreams. So, in fact, the proportions of the beautiful campanile were not enough to free me from the night, my instant attachment to them actually led me into a different kind of dreaming; which is what, right away, I began to indulge. I made that abusive use of formal beauty which I allude to in my book, where I describe these fallacious thought processes as 'gnostic'. It is in the context of these undisciplined speculations that Italy became a part of the *arrière-pays*, and the place where I most abandoned myself to the dream.

At the same time, however, it also constituted the experience that allowed me to free myself from the dream, more or less; and when I speak of my 'dwelling at Urbino' it alludes to this quest of mine. For Urbino is not only the museum where Uccello's startling predella draws us into its abyss, it is also the palace which in its complex architecture seems a veritable emanation of the art of Piero. And thinking about the man who, if ever there were one, is the master of number, leads one on to understand more clearly why he sought, and sought so successfully, to produce a harmony of forms; and how number which is but a dream, the perennial dream of the Platonist through history, can also provide a way out of that dream, but without forgetting, in all this new and suddenly lucid experience, the aspirations that sustained the great mirage. Which is now transformed into the mirror of existence as it really is, not as one would wish it to be—a means of truth.

But how can the beauty of forms escape the snares of the desiring imagination? In the fifteenth century, it was achieved with the aid of the *prospectiva pingendi*,[6] especially as it was applied by certain artists soon after its invention. Of perspective as elaborated by some great Tuscans during the Quattrocento—heaven knows how easily it can be pressed into the service of the fantastic, the

6 Reference to *De Prospectiva Pingendi* (*On the Perspective for Painting,* c.1480), Piero della Francesca's mathematical book on the subject.—Trans.

unreal, the dream—and it soon would be, as Mannerism proves, and as Borromini confirms, and certain aspects of the late Baroque, though in this case more often outside Italy, in German-speaking countries.

But what did the first great perspectivist, who was essentially an architect, actually want? Essentially, the realization of a street, a square, a monument, a town, all of them places where the human community as it really exists might come together, to carry on its business in a public space whose essence is, so to speak, 'diurnal'. At the beginning, perspective was less concerned with the abstract mastery of space than of reinventing the relation between a man and his natural space—and his body— which the purely logocentric thought of the medieval theologians had stifled. It is both an incitement to emerge from that dark night, and a method for doing so—its true contribution is less to space than to light, to the light of day, as it emerges more clearly into the places of greater reason. Like the light on those summer mornings when the world seems to offer itself up entirely.

Which explains, I note in passing, why the inventors of the *dolce prospettiva*,[7] who were all of them builders, were tempted also to try their hand at painting, and a certain

7 Fine perspective. On discovering the science of perspective, Paolo Uccello is said to have exclaimed: 'Oh che dolce cosa è questa prospettiva!' ('What a fine thing perspective is!').—Trans.

Time, humble time as it is lived through here, among illusions of the other place . . . (p. 160)

And I think of Botticelli's extraordinary *Pietà* in Munich (p. 160).

his *Raising of Lazarus*. And next to these, who between them have lifted off the tombstone from the imagination, there are others, creators of great art also, divided within themselves, discouraged but still tenacious, not without the suffering which Baudelaire knew to be the *illustre compagne*, the noble companion, of the beauty he most prized. And I think of Botticelli's extraordinary *Pietà* in Munich. And of Michelangelo, sculpting *La Notte* in Florence. These latter works, that have about them the dream—they are works of the image—as much as of presence. But executed with such lucidity that an intimate contradiction seems to exist at their heart—for example, the deployment of the *pietra serena*[8] by Michelangelo, which is a cold tone in the midst of the warm tones of daylight that bathe his buildings, in other words, it is a metaphor for the night which is lodged ineradicably within that light, unconquered and probably unconquerable. Italian art at its peak, has this lucidity, this watchfulness about it. And it has taught me to see that, in fact, this is what makes it so valuable, and so real, instead of and in place of the chimerical use I had made of it at the start.

8 Grey sandstone typical of Tuscan architecture and sculpture.

The Place of Grasses[1]

At a certain period of my life, nearly forty years ago now, I became involved with an aspect of the imagination which seemed to me then little explored—the dream we may entertain of a 'country' quite different to all those that we know but which we never come across in our wanderings, even though the track we did not take that would have led to it was never far from us, at a crossroads. A quite other country and society but not because of geography or language or civilization. What distinguishes so radically and mysteriously this *arrière-pays* lies in the relation of its inhabitants to the world—otherwise made up of more or less the same words and the same things as everywhere else on earth—such that it could nurture a being we can only feel to be lacking 'over here'. Being is a difficult word. I mean it in the sense in which God conferred being on men created in his own image, as opposed to animals and

1 'Le Lieu d'herbes'. This is a much-expanded version of a paper the author presented at the Cérisy-la-Salle colloquium centre in September 2008. It was later published, along with 'Mes souvenirs d'Arménie' (My Memories of Armenia), in the collection titled *Le Lieu d'herbes* (Paris: Editions Galilée, 2010).

plants, that 'die with the seasons' and are no more than 'vain forms of matter'.[2]

I repeat. There must be an 'over there' because 'over here' such a being is lacking. But 'over there', just as 'over here', is the same simple and fully natural reality. No belittling of this reality is implied in this kind of reverie, no contempt towards the place extending all around us, there is merely the desire to live more intensely what this place, and what nature, offers to us. It is the desire that sharpens Rimbaud's cry—we are not in the world, the true life is absent.

To be clear, this desire, this thirst that is after all metaphysical, can be felt at every fork in the road, and the outer aspects of the sensible world are in no way its cause. But they can sometimes be intensified, because there exist over here certain aspects that seem to incite us to set off in search of this fundamental *arrière-pays,* this other country; there are gleams, clues, signs even, who knows, around us, that appear to be proofs of its existence. Take certain old photographs of monuments or of villages clinging to hillsides, on the horizon. The photographs are old, not because the *arrière-pays* belongs to the past but because such images, technically of poor quality, simplify what they represent, which one would otherwise understand too easily; and one

2 The references here are again to Rimbaud and Mallarmé.—Trans.

can thus invest with some deeper intelligence this woman or this man halted at the edge of a terrace in front of a church in Armenia. The church itself is beautiful enough for us to believe that the master builder himself shared some of that hyper-consciousness which still perhaps survives today, somewhere in the labyrinthine heart of these mountain valleys.

Photographs, but also voices, of the kind one used to hear on the radio, issuing from those cathedral-shaped receivers, voices that swelled and fell away again with what was called *le fading*. With my ear glued to the wireless I became attached to those voices, which from time to time almost faded away completely. Where were they speaking from, who were these beings that sang, and sometimes chanted? Over there, where they lived, was that not the *arrière-pays*? There were place names listed on the turning dial, and I would try to link these voices to them—they were names I could even find on a map—but sufficiently remote and sufficiently other as to be tinged with the absolute. I remember becoming obsessed with the name Aberdeen, and even now I know that I could not arrive in Aberdeen without a feeling of holy dread.

There was also the science of perspective, in the Tuscan Quattrocento—the *dolce prospettiva*: *dolce*, what a fascinating word for it!—and especially its deployment by certain painters, major or minor, who I suspected of using

it with other preoccupations in mind than that of merely putting an image together. For example, the monuments that are simplified according to perspective, because they are at a distance from the viewer, are they modified merely because of distance, or are the remaining, simplified aspects of their appearance a sign, still just perceptible to us, of another way of being, and of existing, in the light here all around us on earth, but which *over there* would be lived more intimately, and be better understood? But I found it was impossible to pursue these reflections further, and confusion invaded my mind, quite naturally I came to think, because here we no longer dispose of or cannot recall those higher modes of thought and feeling.

In a much earlier book, I had tried to describe these phantasms of mine, some of which I had simply dreamt, others I had actually tried to apply. For I am forced now to admit, I was very much given to dreaming in the way I have described, so anyone could say to me, and with reason: 'Are these reveries of yours not simply an aspect of who you are, and no business of ours?' And yet no one among us was prepared to consider that there may be something universal in these things, given how our consciousness of the world is structured. The latter, in fact, undergoes language like a kind of prism through which our perception of what is becomes diffracted and is deformed, or even appears double, tinged with what then

appears to be supernatural colour. Our engagement with reality is disturbed as much as it is constructed by language, in which case the *arrière-pays* would be no more than a linguistic illusion, much as we might speak of an optical illusion. It would be a trick or a turn in speech, something almost impossible to straighten out, which explains how this reverie might exist at the very heart of our relation with ourselves and is not just personal to me.

II

I had already pondered this question of the place elsewhere, and the nature of its otherness, that I imagined radical, in the book I have just mentioned, *L'Arrière-pays,* published in 1972. In retrospect, my treatment of the subject seems to me incomplete, and I want now to take up the threads again, by describing some further experiences which I feel are linked to the 'over there' of the *arrière-pays*, and yet are of a quite different nature.

And what I want to evoke, first of all, is not an elsewhere specifically at all but, rather, something on our side, over here—it is the feeling we sometimes get that the place as it exists in the mind, despite its strangeness, is in fact the same as the place in which we really are at the instant we perceive it, but it exists at a level that is more inward, and deeper, than the here and now of our outward and visible existence. How so? It is worth noting to start with

that the *arrière-pays*, the idea of the *arrière-pays*, is a thought, and is not as such accompanied by any perception, visual or otherwise, since we do not enter into that country, we know nothing of it, even if, as I have just remarked, the phantasm can vaguely attach itself to images or situations or visible places scattered here and there in the real world. It is a thought, nothing more, unsubstantiated by formal representations. But what I have in mind now is anything but an abstraction.

I close my eyes—what do I see before me? Nothing indistinct but something very near and clearly visible. To my left and right are some very ancient stone walls, stretching in front of me all the way to the horizon, which is not that far away, under the fine blue sky of a summer's day. Between these walls and, apparently growing under my feet, there is a stretch of tall, wild grass, with a few nettles, and apparently rising clear of this confusion, three or four scattered rocks. Nothing else, save that emanating from everything I see at this instant is a very strong impression of reality; I am at liberty to assert these things because this vision of mine is not something I have just invented for the occasion but an experience I have actually lived, and one indeed that I have had often. I often see these stones and grasses, and my immediate reaction is always the same—this place exists, or rather it is, and I am in it, it is my *here*, it is even a here that brings with it no

elsewhere. For when I am in it I imagine nothing else, nothing even that might be close by, the other side of these walls to the left and right of me.

Its existence here? Yet it is not my actual life, it vanishes as soon as I open my eyes again, and there is no trace of it in the conscious memory of my past life. Compared to the quality of presentness, and of being, with which I invest without hesitating what I ordinarily see around me, or to what I know I have seen, this is non-being. But absent as it is from my life and knowledge, this place of grasses is nevertheless present, in the sense that it is like a place where I am and not one where I should like to go or where I have been and have kept the memory. Here, in this sort of here, absence and presence coincide. So what is it?

People will tell me once again: 'But it is only an image like the ones we see in dreams. This one has taken form and become obsessional in you because of the psychic charge it has, of which you are unaware! This place of grasses, has a meaning, either of a symbolic nature, like the archetypes Jung speaks of in his analysis of dreams, or else a product of condensation and displacement according to Freudian terminology. Try and find its meaning, and make a kind of mandala of it; or explore your own association of ideas, make a puzzle of the apparently visual perceptions that are in reality nothing more than signifiers in your own personal language.'

But, no! I cannot think in this way, and for one very simple reason—it is that between the different parts of my place of grasses are numberless links that are very tight and hold the whole together in a unity, or better, that rise from every part of them like the tremors in hot air, like an intensity which erases in every visible aspect all that is not of its own pure, immediate self-identity. And I myself am a part of this unity, I feel it within myself, I know that thanks to it I am; more, I am where I must be. These two walls, these grasses, these rocks under the sky, they are absolutely not an image—it is in these moments, for me in any case, a reality, the reality. I come into my own country.

It is not the desire for another place, as in the reveries of the *arrière-pays*. But it is the place itself which is my here and now, erasing any thought of an elsewhere. Such is the nature of this event, which unfolds before me fairly often, and which I am prepared to believe is an experience shared by others besides myself.

<div align="right">III</div>

And there is something else, linked to the experience just described but radically different from it also, in a way that is obviously essential. It is an event in perception which is also purely mental but one that is not produced outside of any context, which is the case with the 'place of grasses'. This one takes form within the flux of reverie, and most

frequently during nocturnal dreaming. I shall call this event the 'beautiful dream'.

We all have 'beautiful dreams', and we all experience instants when, out of the morass of anxiety and the super-imposition of images the dreaming mind produces, out of this tumultuous mixture something simple, harmonious, and welcoming, arises something to which our instinctive response is one of adherence, but also of admiration, which is to a large extent aesthetic.

Note that the ordinary dream, which might be pleas-ant, satisfying, exalting, is not what one might call beauti-ful, and it has no apparent need or desire to be so. Nor does it have the time to be so, for its action is hurried, and numberless currents clash, compete and intertwine, under an arch in our mind that is most often lightless, the flares or gleams that one perceives in them seeming to lack the transparency of vibration we feel under waking skies—they are like signifiers in speech, almost, rather than strands of reality. I experience the night-time dream like an action which never ceases to fork, in which *subplots* insinuate themselves continually into the principal narrative, which is itself always changing, so that on waking the account we give of our dream will never be more than a slender selection among the remnants in our memory, and which are, in fact, more recomposed than retained. But it hap-pens that within this theatre of shadows, among these

evanescent scenes and actors, certain aspects of the natural world or of a person become separated from the flux, and take their place more clear-edged in the stable world of simpler things, within the visible—a lake with its calm banks under a pure sky, for example, a sky lit up this time by real light, which seems to have or really has returned. And the image before our eyes has the effect of appeasing us; we feel with real happiness that there is within it an order, a unity, that it is sufficient unto itself.

'Des meubles luisants, polis par les ans,' writes Baudelaire[3], and that too is to brush against a dream of this kind, in which all is 'order and beauty', and 'pleasure', but also one that is cleansed and freed from its perversions and its remorse. The 'beautiful dream' comes to us and its plenitude is there to be shared. We may be within it alone, but others, or at least certain others, would be perfectly welcome, and the light is no longer just an actor playing its role on a stage, a kind of vestige of day whose meaning would exist merely by association; it would be, rather, the direct manifestation of being in this place we are contemplating or visiting. In this case, too, which is where the experience resembles that of the 'place of grasses', we

3 'Gleaming furniture, polished by the years.' See Charles Baudelaire's poem of an idealized and voluptuous elsewhere, 'L'Invitation au voyage' in *Les Fleurs du mal* (1857) from where these words are taken.—Trans.

have the feeling that it is exactly where we should be. And with it comes, sometimes, the feeling that we have actually lived there, in that lovely country on the other side.

But any resemblance ends there. In the first vision described here, there was no suggestion of order, nor of any harmony extending into any further regions or aspects of the world. One was in the presence of a fragment of the world in the raw state, with no issue onto any mode of seeing that would ascribe to anything some higher or more essential reality rising above the simple objects of sense. To put it another way—the 'place of grasses' can be evoked by words, by the words that name things without going any further than to state what each thing is. There are nettles here, and there are stones, but we don't place them in a sentence, we wouldn't think of doing so. With the 'beautiful dream', on the other hand, it is in the relations between its constituent parts that its value lies, and it requires of us the sentences which would take the names of the things shown in a way that would illuminate its order and tell us wherein the value lies. The difference is radical where they are most linked. At first sight it would appear to be the same difference as that between *langue* and *parole*, between language as such, and our particular use of it. And we must certainly keep this fact in mind if we are to understand the 'beautiful dream', and possibly also the innermost meaning of the 'place of grasses'. But

before that, one or two observations on how thought apprehends empirical reality.

IV

It does so through the intermediary of language, notably by means of conceptualization. We select recurrent aspects of the immense flux of phenomena, we give them names and arrange them schematically; the latter make up images of the conceptualized world that allow us to deploy such formulations in speech. But in doing this, what then remains to us of the full reality of each specific thing? Of its infinite being, what of the thousands of aspects it possesses, and which are not taken into account? And to speak of its finite existence also, what of the ingathering of all its aspects into one by means of chance or grace—since an infinity of them is bound within its garland—what of its unique existence, here and now? But we need to remain in relation both with the infinite and the finite that exists within things, for it is in them and through them that day after day we ourselves exist alongside other people. Are we to reduce these, and everything in them that we love, which we have also in ourselves, to the abstract, externalizing representation of analytical knowledge?

Shall we consent, in other words, to being no more than the 'ego', by which I mean here the schematic view of our inwardness which this entirely abstract knowledge

proposes. Must we not also recall the 'I' which, lodged deeper in ourselves, within the space and time of our lives, with the sense intact of its own absolute and of relationships that the purely analytic intellect knows nothing of? This latter concerns clock time, not lived time, geographical maps and not the actual paths, our own horizon—realities that are fundamental. In each living thing it is hardly preoccupied with its material reality; rather, we are obliged to see the world and even our own psyche as fragmented, as unmeaningful, as an enigma. Why the rose? Why the clouds in the sky, and the stones beneath our feet? Why life and death? Questions without answers as far as the conceptual scheme of things is concerned, and hence our anguish, and to palliate it the desire to possess, and to substitute for being this bundle of mirages, which seems to be consistent. And this is where the dream comes in. The dream of possessing, of representing acts of possession which are, in fact, instants in which we forget what we are from thenceforward forced to undergo day after day.

It is not that I incriminate the concept, which is merely a tool that we use to give form to a place where we can dwell, as well as one we can use to study the material surfaces of the world. I am merely pointing out a bad tendency which can develop within it, the temptation of its discourse to close discussion down, to reduce to the schematic and to produce an ideology existing in negation of our full

relation to what is and to whom we are—negating and thus, almost simultaneously, culpable. A temptation to stifle dissenting voices. A temptation that explains why it was possible to believe, such was the Christian belief, that to eat the fruit of the tree of knowledge entailed risking the fall, a loss of full life.

But why do I feel the need to repeat all this, when what I intend to reflect upon are the memories associated with the 'place of grasses', and those with what I call the 'beautiful dream'?

<div align="right">V</div>

First and foremost, because the predominance of the conceptual in our vision of the world, with its potentially perverse consequences, has no part in us at the start of life. The words the child uses during the earliest years are not structured in this way, I mean they are not articulated or organized in a hierarchy of definition. They simply designate things and beings in their presence, which is lived and not studied. In the case of the little child, the I is not displaced by the ego; and it is not until a certain age, difficult to pin down since it varies from person to person—for myself I place it at around seven years, largely in reference to Rimbaud and to his great poem[4]—that

4 Bonnefoy is referring to Rimbaud's 'Les poètes de sept ans' (1871).—Trans.

concepts come to be laid down, one by one or in little groups within the speech of the early years; they start to crystallize, sometimes all at once, in a totalizing structure that delivers a world picture. A structure which suggests models of judgement, a type of truth, a coherence that can facilitate action, and open pathways to it, and which can only impress and subjugate, thereby distancing ourselves from that former relation we had with our existence and the ways in which we inhabited it, and in which we made, so to speak, our friends and enemies.[5]

The ego triumphs, and the I is put out, but it is at this point that things start to happen which seem to me of an importance quite fundamental, even though they appear to be neglected when considering poetry—and yet they condition it. At the moment of transition between our full presence before events and things and the invasion of our vision by the analytic gaze, certain major components of reality up to then familiar, like beings that will disappear under the schematic dispensation, that the intellect pro- poses for them, come before us, so to speak, to say their 'farewells', showing themselves in their guise as the very presences that our new way of thinking represses but also submitting to the new definitions—for example, the tree

5 The scheme here is clearly reminiscent of Sigmund Freud's tripartite structure—ego, id, superego—and of Jacques Lacan's rubrics—the *Imaginaire* and the *Symbolique*.—Trans.

under which, or, rather at the heart of which, one had grown up, the tree that requires of us that we experience it fully one more time, was now and at the same time a peach tree, or an oak, which is an apprehension distinguishing it from others conceptually.

And thence arises cause for apprehension and confusion. The presence emanating from the original place becomes condensed into the schemes that have now to be considered in relation to others; the unity within these beings and that we receive from them is only now perceptible in a field that must, in one way or another, relativize them. The world which was, yesterday, so intimately lived, and somehow understood, has from now on become, in a deep way, enigmatic. The little garden where we used to play, with its tree, has now become both intensely close and mysteriously silent. A bird sings, we do not know from where, and we are astonished, it is both present and absent. Someone passes by on the road, halts for a moment in the light of evening, and there is the same moment of epiphany but this time hidden in a mystery—for the unity encountered so closely yesterday in everything has now withdrawn underneath an appearance which is visible, but as though seen against the light, an object as much of anxiety as of nostalgic yearning. And this changes our relations with the beings we know to be closest to us, the ones we love the best. Metaphysical questioning comes to over-determine and disturb our Oedipal relations.

A fall, and the mixture in all things of the former clarity and the new enigmatic film that has covered it; and this will remain, whether or not perceived consciously, throughout our whole life. The things, places, beings that sheltered the first seasons of our existence, these dramatic epiphanies remove them as much as they designate them—the first orchard is now just that patch of green foliage over there, the far side of walls that now have no door in them, our future existence is an exile. To put it another way, it is the thought itself, of that original place, that forms within us, since in our exile we are suddenly here, and not somewhere else, while yesterday we were at the centre of the world. It has its place on a map, just like the condition we must recognize as being ours. The idea of the place is born out of our loss of it, and our lack. The same goes for the feeling of immediacy, that speck of the timeless we see glitter over and above the desert of clock-time. Apprehension of the place and the instant are born at the moment of rupture, and they remain etched in our perception of the world and of our life as a diffuse and subdued memory, but it is one that can never be erased. A memory like Baudelaire's *années profondes* or Rimbaud's *journées enfantes*.[6] A memory of the I, before the ego gets established, would use words—sounds—to designate and not to analyze. A memory that will be the source of po-

6 'Deep years', 'infant days'.—Trans.

etry, that search within language for the great forgotten referents that exist beneath the seething mass of signifiers.

I have said all this before. But I say it again because it casts light on the two experiences I have described, and the possibly dialectical relation that exists between them.

VI

What then is the nature of the experience I called earlier, and in a kind of shorthand, the 'place of grasses', the perception, at instants, of something that seems really to exist, or to have done so, and which possesses the clear unity proper to beings—this 'ingathering' of their parts, however numerous, and that can in no way be confused with the more straightforward unity of representations born of the intellect only? I can now explain the 'place of grasses' to myself as the memory within me of one of those moments in childhood when a thing or a situation becomes epiphanic; of that unity about to withdraw under its conceptual covering, and which in doing so speaks itself and shows itself. Possibly those two walls, the patch of field between them, the rocks in the distance under the sky, had marked me, one day in the past, for some reason beyond their simple presence, a word that was spoken perhaps, or another person there with me: emotions today forgotten but which might have their place in other frameworks of interpretation, such as psychoanalysis. In other words, it

may be that this vision of the 'place of grasses' had already been prepared by some ordinary mechanism in the mind that would etch it more easily in my mind than other events, fleeting or not, in my future life. Save that what was lived through then, and preserved, is the experience of presence that as I have said happens at the moment when the conceptual was getting a hold over my mind: an experience which up until then was not thought, or felt as such, but suddenly and fully experienced at instants that become fixed in the memory.

The 'place of grasses' is the retention, at this critical juncture with the conceptual, of the type of vision that is cancelled by the latter in its traffic with the world. In this way it forms a part of that memory of presence which produces within us the poetic sensibility, the poetic project. And if it returns, if it persists in the consciousness, it is possibly, and this is a first hypothesis, because the poetic project requires, if it is to survive, to ensure its meaning to itself, and it must therefore, for its survival, remain attached to memories of this fundamental kind and, by their recurrence, make some kind of a stay within and against a discourse set on reifying all things. These walls, stones, tall grasses, represent the inscription the poetic makes of its intuition, and its necessity, within the space of conceptual thought. And because these things which were fully visible in the past are now at risk, from this moment on,

of submitting to the later kind of thought, by which I mean they become no more than an image, obscuring thereby the depth of being they are charged to express, it becomes necessary that the one who has lived them unceasingly plunge back into them, so to speak, and thereby bring back from them the memory that there is a unity on this earth, which is the root of our being in the world.

And this is indeed what I have tried to do, as far as I have been able. Frequently in my writings, and in my life, I have returned to grasses growing wild, to old walls and stones. To a sky like the one I see above a certain place, which recalls its absolute. I could even evoke other memories of the same kind, that work in the same kind of way to those in what I write. I can see a body of water, beneath the sky. The water is running rapidly, and its dark green looks murky. Is it a narrow stream, or a great river, I don't know, and I try to recall—not in order to focus the anecdote, or to remember where it happened, but to live more fully than I can do today what this flood produced in me of anxious concentration as I looked at the gleams and shadows, at blackness in the most brilliant light.

VII

So much for the 'place of grasses'; now for the 'beautiful dream'. With the same premises in mind, I would say that

what I call the 'beautiful dream' is also a memory from the period when one being in the world has an end and another becomes established; but what is meaningful this time are no longer instants of full presence in a thing or a place, but the imprint left in the memory by the thought succeeding them. What thought is this? That within the new mental space, that of the intellect, of fragmentation, we shall lose the resource of the former world, where all is presence, where all is unity; this primary world that disappears behind walls above which one sees nothing more than the tops of the tallest trees, and we ourselves are already on the roads of exile. There had been, just yesterday, a golden age, one in which *la chair* was 'un fruit pendu dans le verger'[7]— to borrow Rimbaud's wonderful expression for that early continuity between the human being and the world—and now we are in the age of iron.

Let us pause in an effort to understand this impression, and emphasize at the outset that it is for those who experience it, and who more or less consciously acquiesce, a form of privilege. If one has been a victim during childhood of poverty, hunger and any kind of violence, is it possible to have anything but painful memories? The recollections I have been speaking of are something of a luxury, in our experience of the world, which may cast doubt on their

7 'The flesh . . . a fruit hanging in the orchard'. See Rimbaud's 'Sonnet', part II, of 'Jeunesse' in his *Illuminations*.—Trans.

right to have in any way a claim to the truth. But I also know that one can retain affection for one's early years, even though one may have little call to do so, and few happy memories to keep. In fact, the poets most intensely devoted to the work of memory in this way are almost always those who have to engage in a strenuous process of transfiguring penury. And this too must lead us to consider further.

What exactly is the regret that so frequently follows upon early childhood? To attempt a reply to this question, we must first recognize that the original place, the world that is a plenitude all unto itself, even as it departs, consists of two levels, that can be differentiated later on. The first, and the deepest level, is where we encounter those apparently simple and autonomous realities that the giver of language had inscribed from the first day in her great book —sky, tree, stream, numerous animals, a few flowers and some beings we understood to exist everywhere on earth and who will remain through adult life, except that they become veiled by other interests and anxieties. In our early days, these realities may well be presented in specific forms; they are nonetheless universal, and aligned with the words which name them, names that are previous to any conceptualization. We can say that, in the child's perception of what is, they exist alongside, and at the same level in the understanding we have at that time—composites, not of an

analytic or pragmatic language but belonging to a kind of *logos*, in the religious sense of this word when applied to a world created by God that is visible, ordered and composed of the immutable essence of being.

But there existed not only those *vivants piliers*[8] of our earliest memories. Of a nature distinct from that of the tree, and despite all the elements they seem to have in common, is the path that runs past its foot, because its twists and turns are related to those beings that traced it, and to moments in history, and thus subjected to the hazards of time, quite as much as to the timelessness of the hedgerow or the grass. It leads to the door of the house, and the house—with its furniture, and all those objects that can seem strange and astonishing to the child, and the grown-ups in the rooms and bedrooms whose shadows are still perceptible, and whose voices are almost audible— the house itself we know to be, and we knew it early on, what is both most real about this past that falls away, as that which gave it a centre and a meaning; while at the same time it is less intense in our experience of its being, as the tree or the stone. And from thence there springs, always, an anxiety, a fear.

What is this fear? The trees will be there always, and many of the paths, but the people are dead or will die, and

8 'Living pillars'. See Baudelaire, 'Correspondances' (1852–56).—Trans.

the house demolished, and the same place that today gives itself to them with generosity and with an apparent complicity, will then forget them, and time is no longer a summer day that begins and ends and begins once more, but a river that runs beneath black arches to the sound of fearful rumours. 'Don't let my mother die!' says the child, repeatedly, very early, in fact, after first emerging into consciousness. And this awareness comes from a different level of reality, in which non-being has penetrated being. What was a plenitude and a certainty is suddenly shadowed by the unthinkable—that these beings, experienced as absolutes, will not only one day cease to be but they might never have been. What is, might have been quite different —the world is subject to chance.

So the other face of the lost reality consists of these people and even these things, these beings that have no being, and this absolute that is nothing but chance. So a kind of strata of unreality has opened up within the real that is constant and elementary, where nothing died and a few big simple words were enough. There is now a world where sentences are necessary, because the people we love and who will die, or who have died, can only establish themselves in the memory because we can speak of them—we speak of them in order to think of them. Language comes to birth with our experience of chance, or of non-being, whether we admit it or whether it remains still concealed from us.

And the thought of the One, of the Unity, our sense of its presence in everything and everywhere, does not die away either, it remains vivid—and that is the enigma which sends a shiver through the epiphanies of the last days of childhood. A shadow has penetrated the light, there was a snake in the grass which has bitten the heel of Eurydice.

VIII

Two levels, then, in what remains within us of the origin. Less an unfailing plenitude than a caesura that gathers around it a few presences, both essential and yet ghostly, inconsistent—shadows of a moment crossing the fixed decor of a stage. What of our own, personal world, the crucible of all our memories? Nothing but a drawing made with three pencils on a sheet of paper that the wind carries off, along with many similar sheets.

And at some moment in adolescence arises another question, one that is still more dismaying. The path itself, behind the house, and the trees, even the trees, and the sky, the whole sky, everything that constitutes the background against which the beings stood clear, the basic primary things in themselves, in the plenitude of their being—is that background not also part of the drawing, are they not mere vain forms, less something imagined as fundamental than something else created by humans? The question strikes suddenly, and the answer comes back

irrefutable, alas! The lovely constant majestic world is, in fact, only what the mind, through successive choices and through ceaseless work, has raised out of what is otherwise mere chaos, infinitely fleeting and centreless and absent. The decor is no more real than the scene played out upon it. And what is the true background? The violence of primitive life forms, joyless predations, the collapse of beings without self-consciousness back into the gulfs of matter, mere chance sovereign everywhere and in everything. And the darkness is so thick that it rises, with its ravening insatiable cruelty, which can bring us to the brink of despair, into the highest levels of organized societies, whatever the values they claim to defend. To think chance through, to think the arbitrary through, carries us a long way out. And memory, too, is an abyss.

Not so fast! I shall be told, and I shall tell myself. It may be true that the house we were born in, and its inhabitants, are no more than vain images, still we love them, and that is itself an absolute, one that can be a building block in the construction of our world, whether or not it rests on non-being—as such it shall establish its reign beyond destruction. Further, we must ourselves decide, in our seasons of doubt, that the network of images—our own and the numerous others we meet in our societies, that we have verified and believe that we can share— well, however unreal it may be, it is being itself, being that

resides on our willing that being there should be, a being that must turn away from the question of what founds it, and devote itself to its choices, among which it must live, from instant to founding instant, as it builds its own earth.

Yes indeed, this is being, this is of course reality. Not a fact established but an act. An act that consists in acknowledging the existence of other beings, in the recognition of their presence, which means that we no longer accede to the world by matter, or by the externality of matter but, rather, by the other existences we encounter and the unity that sustains them. It is a unity that enables mutual recognition, and creates bonds and produces meaning, which is a source of comfort when in our lives the external triumphs through death or in those black impulses we see rise up out of the abyss. Reality does not consist in the numberless signifiers that lack being but, rather, it exists in meaning. Meaning understood as that which invests our acts with positive assertion; just as, in language, meaning constitutes unity on the path to selfhood.

And meaning understood in this sense applies also to our relation to images, something quite other than acknowledging their illusory nature. Of course, we must not forget that they are built out of concepts which blind them to the specificity of beings, and replaces the specific with generality, which can make them incomprehensible and doomed to vain beliefs and then to the apprehension

of nothingness—in which case we are obliged to hold them in anathema. And yet we can also remark the fact that, frequently, they cling tight to the presences that we love so much—which mean the world to us, as the saying goes—so that they, too, speak in their way of that unity without being able to join it: and so, no, let us not condemn them but, on the contrary, let us help them to wake up out of their dream, let us not refuse what they say and listen to the desire they express. And the help we bring to the image is what we call poetry.

Poetry is the memory of those instants of presence, of plenitude experienced during the years of childhood, followed by the apprehension of non-being underlying those instants which becomes translated as doubt, and then by that hesitation that constitutes life; but it is also a reaffirmation, it is our *willing* that there should be meaning at the moment meaning falls away. This takes work, certainly. A long exercise of trangression within the image, not in what it contains of the conceptual but in its tendency to close upon itself, in its self-mirrorings, in its illusions. The task involved is called writing, because words are necessary to deploy fully the dreams in which the desire for being aims to release the intuition that keeps it alive. It is the task of a lifetime. A difficult task, because sometimes the chaos outside batters hard at the panes. There are days, even in poetry, when faith in being is lost.

IX

And it is here, via a long detour, that I can return to what I have called the 'beautiful dream', with a better understanding, on several levels, of what it means. I suggested earlier that the moment of harmony, of peace, of total sufficiency, was fed by our memories of childhood, and of the feeling that there existed then, as William Wordsworth writes in 'Intimations of Immortality' (1807), something that has fled away in adult life; and in these further remarks I have now come to believe that the lake in the distance which I have taken as my example of the 'beautiful dream' is in its very beauty, a denial of the apprehension of nonbeing that puts an end to childhood, a rejection of that pessimism. So naturally and peacefully do its banks and waters reveal the harmony, the light, the transparency, right into the depths of the real.

But is the beautiful dream merely a denial? It is so lovely, sometimes, is it not too much so to be just a mockery? And may it not mean that the anxiety it inspires has stimulated a desire to explore its limits, even if on this occasion it has to admit to perceiving only a mirage? The far lake initiates further thought. Revealing that the dream persists in what appears as reality; placing the question of the image at the very heart of what is.

I believe that this is so, and that it is a truly poetic postulate, one that paradoxically intensifies these dreams,

these too-lovely dreams. In other words, I believe that such promptings are, despite appearances, less a trap than a test that sets us squarely before our own freedom of choice; that seeks to remind us that we ourselves must reinvest the universe with being. So the lovely dream comes to try us? Yes, and this will be my last remark, in an essay that is already surely over-ambitious—there is no configuration of sensual data, no mix of images, memories, hopes or dreams that comes to us without it being affected by a radical ambiguity, and one that will decide our future.

Our perceptions of the 'lovely dream', assembled as they are by our desire, gathered in under our gaze by the very fact of their beauty, into a unity—we see them manifestly as a form: the lake, and its banks are a harmony, as I said, and thus a form. And the hope that stirs along with this, is also a form, in response to beauty, to that enigmatic beauty of which form is manifestly capable—is form itself not the key to our acceding to more reality, to more intense being, to the true life?

However—and herein resides the ambiguity I shall talk about—form can only ever be associated to a content from which it becomes detached. And it is our apprehension of this content which will decide the ultimate nature of that form, and the use to which we wish to put it and the sort of reception we can reserve for the lovely dream; and then it will have a say in what effect it has on our existence.

Essentially, the realization of a street, a square, a monument, a town . . . (p. 154)

To put it another way. To everything that comes under our gaze, we can, in fact, and we do at every instant, give two readings that are actually opposed. First, we can regard the objects we see from the point of view of conceptual thought merely, reading it off according to our different senses, constituting it as a distinct object, detachable from its embedding in place and time, and thereby rendering it available for generalization and speculation. This type of thought can transform, say, that house on the hill, with its trees, into something less than its existence in the world

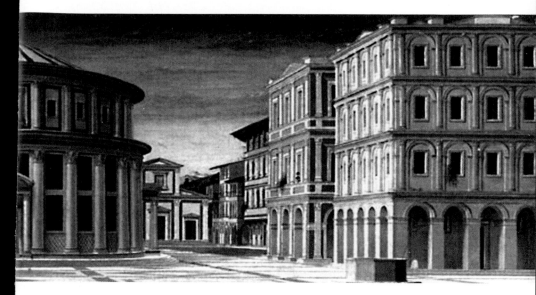

here and now than the basis for a dream in which other horizons, other and superior worlds may be imagined— the harmony already latent in the landscape recruited into a project that transmutes the world according to the dictates of number and proportion. This is the way that Platonism, our eternal Platonism, operates. It would make of beauty a denial of the place itself, where we had the experience, now stamped with imperfection and death.

But the horizon line which shows the lake in the distance, why do we not also remember that it is the edge not only of a world of essences but of existences; not only of visible appearances but also of beings living alongside;

a world that society can in no way penetrate to its darkest depths of indifferent nature, and yet would make its own, investing it with projects, aspirations, values? After all, we have seen the fine lake within its lovely banks at many different moments of our lives, and it comes to us charged with those memories, and those moments of our past, and to which even our present desires are attached, and that speak to us, now within our normal condition, which is the one that time ravages but where it can also flower again!

So what then is the form, as it emerges in this other field, still embryonic, still unaware of its powers, involved as it is in all our acts, even the most ordinary and everyday, structuring them and illuminating the relation of the individual to his or herself through all the ups and downs of life? What then is this form, and what is its occasional beauty? Just another image? And who, over there in this vision of the lake and its banks, shall give themselves up, yet once more, to a dream? But this time the dream will be entertained in the hope of a new relation between being and being, at the heart of shared time. It is the dream of a coming together, of a possible harmony, uniting the different needs of men and women in society as it is. At the very least such a design will implant itself in those who imagine such a maturing of the relation of self to self in this sublunary world. A thinking that can make its mark,

in the very here and now. A thinking about form, no longer Platonic, but, rather, 'Albertian', after the great architect who, along with Piero della Francesca, turned the mind away from metaphysical Platonism to make numbers, and the affectionate relations between them, the material with which to build the human city, using courage and reason.[9]

So is this project just a dream? Yes, in that we never go further enough into it, and we grow impatient and start to anticipate. But the dream has now become a preoccupation of existence, no longer merely speculative but as it is lived. And, in spite of the illusions it would lure us with, this time we have duly confronted and passed through the ordeal of what I call the beautiful lake, the too-lovely lake; our eyes shall be wide open in what was, an instant before, just an excess of the visible, and if they close once more we shall know that we must quickly recover ourselves. It may be fatal, with the truth scarcely glimpsed, to find ourselves once more battling with the temptation—to live from without, and externally, whatever form suggests to us. But we are now armed with some ability to guide ourselves, when faced with these crossroads—a sharper, more

9 Bonnefoy returns frequently in his writing to these two masters of perspective. Leon Battista Alberti's Tempio in Rimini and Luciano Laurana's Ducal Palace in Urbino, both places deeply familiar to Piero della Francesca, represent the *summum* of sacred and civic architecture.—Trans.

dialectical feeling about what is at play beneath the beautiful surface, even when it seems to us unlined, and perfectly smooth.

<div align="right">X</div>

Coming to the close of these remarks on the mind's temptation involved in the 'over there', I shall now venture one further hypothesis, which shall be on beauty itself, on its essence. I have had the impression at moments during the foregoing analysis, and dismantling, of the lures that I was drawing near the elusive centre of what we experience as the beautiful, which is always by having recourse to forms.

Why do certain works, the facade of Alberti's Tempio Malatesta, or Michelangelo's *La Notte*, touch us in quite such a way, and so inwardly when the obvious beauty of their external form should reveal their whole meaning on the surface? What secret do we divine within and why and how do we have the impression that they conceal rather than show it—requiring from our own gaze that it understand almost in a whisper what they seem unable quite to utter?

Well, it is because the two ideas about form that I think I have perceived in the experience of our being in the world—the one which deals in the appearances of things as separated out and made distinct by conceptual thinking, and the other that remembers their existence, their absolute

right to being—both haunted Alberti and Michelangelo. It is because both approaches solicited, tempted and even invaded them, at successive moments of their life, or no, simultaneously rather, always at the same time, neither of them backing down before the other—and to listen to their siren calls, was for them to suffer the tension, to think it through and so develop, confronting every aspect of their condition. The works of these artists, who are also poets because of this process, are less the result of a freely chosen idea that finds expression through the harmonies of form than the result of unceasing and unresting argument. And the beauty they produce is less the result of a search for perfection for the eyes than a seismograph recording the stirrings, rumblings, rockfalls and storms thrown up at every strata of their being. Is form in their works beautiful? Yes, but not at all as a crystal or a shell is beautiful, which belong to the deserted perfections of number left to itself. The beauty of these works lives and has its value from the almost imperceptible shudderings which touch us all the more, because they exist on the same level for us as waves of fear or shivering fits when we have a fever.

Alberti, Michelangelo. But also so many pondered works by Poussin, or, as Baudelaire well knew, all those statues by Pierre Puget or paintings by Delacroix or Van Gogh, Mondrian, Giacometti, who stand out against the apparent distaste today for the question of being and

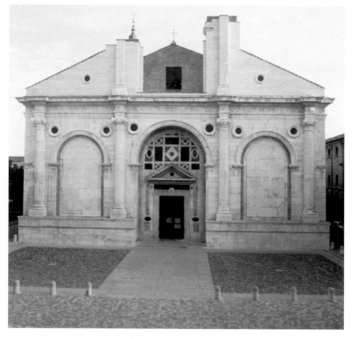

The beauty of dynamic form exists in this tension, this struggle . . . (p. 201)

non-being: there is no artist, or explorer worthy of the name, that is in itself so ambiguous, who is not thus torn, and who thereby reveals the nature—through all the torment followed by relief, the breakthroughs, the lights, the cries of pain and the crises of renunciation that still recall everything that has been given up—of the beauty that they pursue along two rails that perpetually diverge and come together again. Beauty, in this art that is also poetry, is the

beauty of dynamic form, and exists in this tension, this struggle—the refusal to be carried away by the dream, by the aesthetic, due to moral exigency, and then the defeat of this latter by the thrust of desire. Sometimes there exist fragile advances into a greater maturity, but nothing can ever wholly cancel out this duality which is, after all, the fate of each and every speaking being—language itself representing the obligation we have to externalize when it also keeps within it the memory of its original organic unity.

Beauty is truth. We must not forget it, for to do so, when we apprehend acts and works, would mean that darkness would come down upon our words.

My Memories of Armenia[1]

<div align="right">I</div>

Our memories do not always convey the impression that they have some relation with our past. Of some of them we can say that they seem to surface from a deeper and wider gulf than this, they seem, even, to have happened before we were born. But there is no mystery here. My own belief is that these apparently unsituated memories reach us from the period of early childhood, when notions or concepts did not have the amplitude and coherence they attain later in order to deliver to us both a world and an idea about ourselves. We might even say that, at that stage, we were still upstream of what we later call our personal history.

Things, beings, events were perceptible to us, and would astound us and, while we could not analyze them with the powers of an adult, they were there, silent, before us, with neither after nor before in the span of our existence, and bearing no relation to the surrounding reality—they exist, in short, as pure presences and, at the same time, closed off from the others, and full of enigma. Which is why, today, they seem to exist outside of our past

1 This is a slightly abridged version of 'Mes souvenirs d'Arménie' (2010), which the author wrote for the Armenian translation of *Rome, 1630*. It was later collected in *Le Lieu d'herbes*.

and yet constitute a piece of our origins. Thus I think of an image which, from one second to the next, surfaces within me and it springs from this special type of memory—between two walls of unadorned windowless stone, and covered by a thick growth of tall wild grasses, there is a deep and narrow yard beneath what seems to be a summer sky. The place is deserted, abandoned. It seems to be a memory and indeed it may be that it has some reality linking it to my life, some fleeting moment of years long past, and yet I know I shall never find the thread leading back. It is as if it existed somewhere outside the world.

<div align="right">II</div>

But we also have memories that we are able to localize, with precision as much as certainty—and yet, the strange thing is, these memories cannot possibly be a part of our personal history, and so they must belong to that same absolute elsewhere I have just described.

A memory of this type rose up in me, suddenly, when I first encountered the churches of Armenia, at the end of the 1940s. I saw these churches reproduced in photographs, but I was convinced at the same time that I had seen those facades, and those apses, and those great irregular stones, sometimes sculpted, and those horizons beyond them, and that I had seen them in my real existence but had entirely forgotten about them until that instant.

The reproductions I speak of were in black and white, containing few details (p. 205).

I would have seen those photographs in books of architectural history, devoted to the early centuries of Oriental Christianity, that appeared in English, German and French at the beginning of the twentieth century. And I know exactly why they would have captivated me so— primarily because the buildings are extremely beautiful, and very satisfying to the spirit. Such is the harmony of their proportions that one cannot but ascribe to the master masons that designed them a great discipline both of thought and life. The lesson learned from the stone, that eternal matter scattered over the mountain slopes or

bathed in the fresh water of the ravines, is comprehended here and transmuted into the development of form.

But it was not so much the beauty of these buildings that affected me the most at that moment, so much as my feeling of *déjà vu*, and of familiarity, as if I had known them already. And today, now that some of my books are translated into the Armenian language, I deem it useful to ponder this illusory reminiscence that for a long time disturbed my relationship to things and which may still do so.

<div align="right">III</div>

I think I now understand the more general reasons that would explain this pseudo-memory, and the hand I sensed behind me, and which had touched my shoulder so suddenly and so firmly. These illustrated books dating from the first years of the twentieth century were not in colour as they were to be a few decades later, together with so much information on so many aspects of the places and things that those looking at the photographs can enter into the image without having to dissociate themselves from their own existence and ways of thinking what this existence bound them to.

No, the reproductions I speak of were in black and white, containing few details and, due to the poor quality of the paper, which was in any case old, there was even

something grey about the light. It is not possible to enter into those images without breaking away from the place where one lives and from the person one is in daily life. And one is thus projected onto a plane where, by suspending one's ordinary preoccupations, it is easier and perhaps even compulsory that we ask deeper questions to do with our being in the world. The reproduction in black and white stimulates us to think about the meaning we attribute to life, whether we are merely nothing, or if we can aspire to being. Of the picture black and white gives of the world, it creates a *cosa mentale*, an experience in the mind, at the heart of which aspirations of a metaphysical nature begin to stir.

The character of these old illustrated books means that we can see them in a way that links them to those 'absolute' memories I spoke of earlier, the ones we have before the conceptual network delivers the world to us and enables us to construct a past. The status of the object in black-and-white photographs—to sum up—belongs, rather, to the order of being than to that of the object; we are invited to see in what these evoke not things to be understood, as in adulthood, so much as to be felt intensely, as before the presence of being, in those moments of childhood that remain vivid in the mind. We are summoned to the same kind of experience as that which haunts the memories of pseudo-childhood, and

we recover in the same background of the memory things that give the impression of having been lived, but outside of our life and yet within it.

Such is the harmony of their proportions . . . (p. 204)

In short, I had the impression I had already visited these churches, among their mountains, because the black and white established a continuity with other memories from those 'profound years', reminiscences that seem to spring from 'before we were ourselves'. And why should it be these images of Armenia which gave me this impression, and not any of the numerous others I saw at the same period? Because the beauty of their architecture represented already

existence. But it is easy, and I have just given an example, to enjoy them for their remote, mysterious quality, and to turn them into dreams which, at least for a while, allow us to escape the task of incarnation. To dream that one lived in Armenia as a child is, first and foremost, perhaps to dream of becoming a child again, before that task turns into a necessity.

<div style="text-align:center">V</div>

At this point I rejoin my 'memories' of Armenia, and primarily of photographs in general, old photographs. How easy it is, in fact, for images of this kind to set us dreaming; to start us imagining that civilizations of which we know almost nothing are places in which the mind is not subject as our own is to irremediable constraint! And to get the better of these mirages we must submit ourselves to a critical enquiry involving the lure that can tempt us, inherent within every image; but also to one that concentrates on each particular image among those that have seduced us, because we have found a fleshed-out reality in its speciously schematic traits, which are simply ordinary, of the thing it is supposed to show us, as with photography!

I have suffered much, myself, from the lure of images. But I have been able to struggle against it by acquiring, wherever possible, the kind of knowledge that art history

or the history of civilizations, religions and myths can deepen—the collected mass of exact knowledge that places the remote object back in continuity with all the others at the heart of the single world, whose centre is where we are. I am no historian, but my main concern is poetry— that counters dream—and that seeks aid from historical research in that labyrinth where metaphysical reverie would lead it.

It is with this purpose in mind that I undertook to study Italian art, for instance. The notion of a society with a greater lucidity than ours is capable of came to me partly because of my all-too-vague knowledge of certain parts of Umbria or Tuscany, the villages, and small towns which, at the time around the middle of last century when I travelled there, were still quite difficult of access. And so I devoted myself, as an amateur, to furthering my knowledge of this art, one fundamental aspect of which was precisely to yield, often consciously, to deceptive reveries of the same kind. So much so that by studying them one comes across artists whom, all enflamed by their dreams, teach us how to live here by sharing their experience, which is sometimes a deliverance, an achieved incarnation. I spent a good deal of time in the company of Piero della Francesca, of Bellini, of Bernini. And I saw in Poussin, who came into Italy with ideas similar to mine, it seems to me, a painter who could guide me into a self-acceptance of our finite nature.

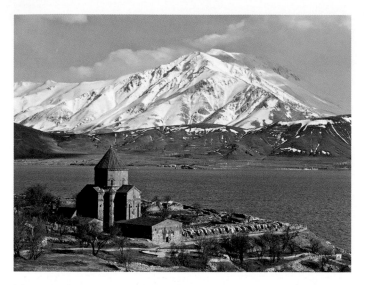

That eternal matter scattered over the mountain slopes . . . (p. 204)

But Armenia! Armenia of my memories of another life! At the extremities of this call from inland Italy, and even a little before it, this most ancient of outposts of Christian power lay behind my idea of the *arrière-pays*. It was those photos of churches like T'Alin, Achtarak, Odzoun, standing there in those solitudes, which set me on the path of this reverie, and it was starting from them that it spread to other horizons in that part of the world. It was thus Armenian architecture that I should have tried first of all to repatriate into ordinary reality, by studying it more seriously, by deepening and diversifying my knowledge of a society and its artists.

I did not make that effort but I have excuses for not so doing. Italian art was easy to study, because the books that treated it were mostly in English, Italian or French, and in the case of Italian I had the poets who could help me reach deeper into Tuscany or the Marches or Rome, and thereby better understand these works. And ramifying outwards from Italy my horizons widened and my interests reached towards other regions of Europe, until I had more than enough to work on. Armenia, on the other hand, did not come to me like Italy, with words and etymologies already familiar, which enabled me to study the substrata of the thought as well as the works themselves, and to verify that the motivations and intuitions at work in them are the same in us still. But it was my ignorance of the Armenian language that barred me from access to the Armenian kingdoms, and I never even dreamt that I should learn it.

At the same time I am aware how an unknown language and, what is more, one that exists in an alphabet I do not know, is enough to rekindle the dream of some transcendental elsewhere, and of the fusion, far 'over there' of the absolute with the sign. And I am inclined to believe that if I have not really tried to find out more about Armenian civilization it is because someone within me is reluctant to put an end to a reverie, so familiar to me now it was possibly essential to my first explorations in writing.

Poetry, to which I try to remain faithful, is the going beyond, the dismantling, of more or less chimerical representations which weigh poems down, but they are nonetheless a rite of passage in fulfilling one's own poetic ambition, which can become attached, naturally enough, to what it must combat.

Armenia still moves me. I know that it is simply—so to speak—one of the great civilizations of our real world, somewhere I could actually go, and meet real beings, and speak with them of problems that exist everywhere else on earth. But I cannot prevent myself from keeping what I know of it within a kind of nimbus, like the figure of a saint in an icon.

'She looks pale. Again, she tries to catch his eye.'
Fayum mummy portrait (*c*.100 BC).

'He had not, however, dreamt it.'
Detail from Piero della Francesca, *The Flagellation* (*c*.1459).

'They claim that places, like gods, are only the stuff of our dreams . . .'
Buddha statue, Horyuji Temple, Nara, Japan (seventh century AD). Photograph courtesy Yves Bonnefoy.

'Where wells have been sunk, or cisterns sealed . . .'
Desert reaches. Photograph by Lorand Gaspar (n.d.). Courtesy Yves Bonnefoy.

'Those humble clay-and-wattle domes after miles and miles of salt and broken stone . . .'
Desert dwellings north of Qum, Iran. Photograph courtesy Yves Bonnefoy.

'It is an earthly path, that belongs to the earth itself.'
Edgar Degas, *Landscape* (1890–93).

Detail from Nicolas Poussin, *Mercury, Paris and Cupid* (*c*.1660).

'The audacious, abstract use of perspective . . .'
Detail from Paolo Uccello, *Battle of San Romano* (*c*.1450).

'His over-elongated shadows . . .'
Giorgio de Chirico, *The Mystery and Melancholy of a Street* (1914).

'Grave, serene, almost upstanding in their flawless presence . . .'
Domenico Veneziano, *Virgin and Child Enthroned* (1440–44).

'Just a few score kilometres from here, or less perhaps . . .'
Church of Santa Maria, Portonuovo, Ancona. Photograph courtesy
Yves Bonnefoy.

'But no, the sun came in everywhere . . .'
Detail from Piero della Francesca, *The Baptism of Christ* (*c*.1442).

'In back numbers where the photographs are smaller and
greyer . . .'
Giovanni Bellini, *Virgin and Child* (*c*.1490).

'As I did recently Rosso's *Deposition* in Volterra . . .'
Detail from Rosso Fiorentino, *Deposition* (1521).

'Who has drawn closer to the threshold than he?'
Detail from Arcangelo di Cola da Camerino, *Crucifixion* (early
fifteenth century).

'The wounded teacher . . .'
Detail from Michelangelo, *The Night* (1520–25).

'At times so tense, impatient, black, and at others reconciled . . .'
Sandro Botticelli, *St Mary Magdalene at the foot of the Cross*
(*c*.1500).

'Without doubt his most irrational, and most inspired . . .'
Nicolas Poussin, *Moses Saved from the Waters* (1651 version).

'The same half-crushed coal had been scattered in the grass.'
Nicolas Poussin, *Moses Saved from the Waters* (1647 version).

'Anne, with Mary, has that smile, on her lowered, half-turned face.'
Detail from Leonardo da Vinci, *St Anne with Virgin and Child* (1506).

'In its intense definition, in its existence as a sign without meaning
. . .'

Detail from Théodore Rousseau, *Plateau de Bellcroix, forêt de
Fontainableau* (1837–48).

'And, as before, its eyes astounded me.'
Detail from the *Sphinx of Naxos*, Delphi (sixth century BC).

'A marvellous late afternoon warmth.'
Miklos Bokor, *Composition* (1962). Courtesy Yves Bonnefoy.

'No, because it operates beyond words.'
Detail from Titian, *Adam and Eve* (*c*.1570).

'That would be the crucible in which the *arrière-pays*, having dis-
solved, would re-form.'
Piet Mondrian, *The Red Cloud* (1907–09).

'Of a metropolis, *over there* . . .'
Edgar Degas, *Italian Landscape Seen through an Arch* (1856).

The Labyrinth, Cathedral of San Marino, Lucca (twelfth century).

'Into the service of the fantastic, the unreal, the dream . . .'
Church of Sant'Ivo alla Sapienza, Rome (1642–60).

'Time, humble time as it is lived through here, among illusions of
the other place . . .'
Caravaggio, *The Raising of Lazarus* (*c*.1609).

'And I think of Botticelli's extraordinary *Pietà* in Munich.'
Detail from Sandro Botticelli, *Pietà* (*c*.1500).

'Essentially, the realization of a street, a square, a monument, a town . . .'
Unknown Artist, *Città ideale* (late fifteenth century).

'The beauty of dynamic form exists in this tension, this struggle . . .'
Tempio Malatestiano, Rimini (*c.*1450).

'The reproductions I speak of were in black and white, containing few details.'
Church of St Gregory, Ani, Turkey. Photograph by James Gordon.

'Such is the harmony of their proportions . . .'
Armenian Church of the Redeemer, Kars, border of Armenia and Turkey. Photograph by Sedrak Mkrtchyan.

'That eternal matter scattered over the mountain slopes . . .'
Armenian Church of the Holy Cross, Lake Van, Turkey.